DEFENSIVE
NORTHUMBERLAND

Colin Alexander

AMBERLEY

Front cover: The north gate of *Vercovicium* Roman Fort (Housesteads).
Back cover: Ford Castle.

First published 2018

Amberley Publishing
The Hill, Stroud
Gloucestershire, GL5 4EP

www.amberleybooks.com

Map illustration by Thomas Bohm, User Design, Illustration and Typesetting

British Library Cataloguing in Publication Data.
A catalogue record for this book is available from the British Library.

ISBN 978 1 4456 7228 1 (print)
ISBN 978 1 4456 7229 8 (ebook)

Typesetting and Origination by Amberley Publishing.
Printed in Great Britain.

Contents

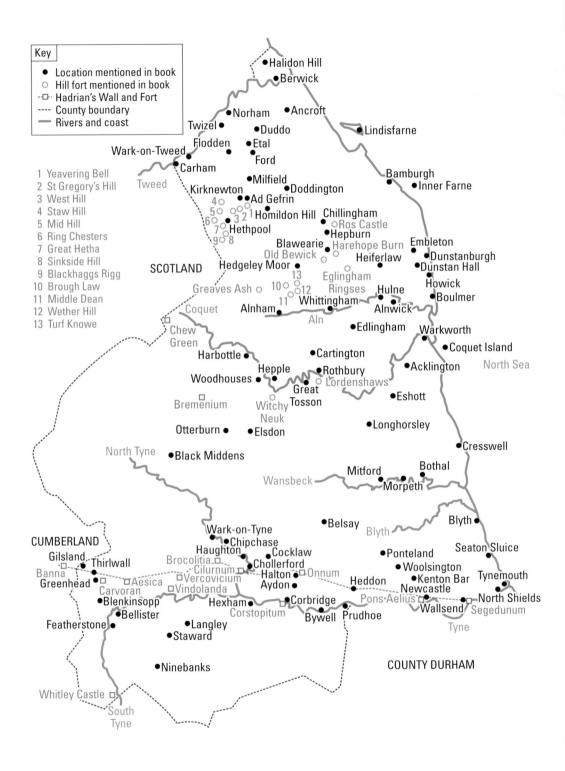

Key

- ● Location mentioned in book
- ◌ Hill fort mentioned in book
- ▭ Hadrian's Wall and Fort
- --- County boundary
- ▬ Rivers and coast

1 Yeavering Bell
2 St Gregory's Hill
3 West Hill
4 Staw Hill
5 Mid Hill
6 Ring Chesters
7 Great Hetha
8 Sinkside Hill
9 Blackhaggs Rigg
10 Brough Law
11 Middle Dean
12 Wether Hill
13 Turf Knowe

Halidon Hill
Berwick
Norham
Ancroft
Twizel
Lindisfarne
Duddo
Flodden
Etal
Wark-on-Tweed
Ford
Carham
Milfield
Bamburgh
Kirknewton
Doddington
Inner Farne
4
Ad Gefrin
5
3 2 1
Homildon Hill
Chillingham
6
Ros Castle
7
Hethpool
Hepburn
Embleton
9 8
Blawearie
Harehope Burn
Dunstanburgh
Old Bewick
Heiferlaw
Dunstan Hall
SCOTLAND
Hedgeley Moor
13
Howick
Greaves Ash
Eglingham
Hulne
Boulmer
10
12
Ringses
11
Whittingham
Coquet
Alnham
Alnwick
Aln
Warkworth
Chew
Green
Edlingham
Coquet Island
Harbottle
Cartington
Acklington
North Sea
Hepple
Rothbury
Woodhouses
Lordenshaws
Great
Eshott
Bremenium
Tosson
Witchy
Neuk
Otterburn
Longhorsley
Elsdon
North Tyne
Black Middens
Cresswell
Mitford
Bothal
Wansbeck
Morpeth
Belsay
Blyth
Wark-on-Tyne
Blyth
CUMBERLAND
Chipchase
Seaton Sluice
Gilsland
Haughton
Cocklaw
Ponteland
Brocolitia
Cilurnum
Chollerford
Woolsington
Banna
Vercovicium
Halton
Onnum
Tynemouth
Greenhead
Aesica
Heddon
Kenton Bar
Carvoran
Vindolanda
Aydon
Newcastle
Blenkinsopp
Hexham
Corbridge
Pons Aelius
North Shields
Bellister
Corstopitum
Bywell
Prudhoe
Wallsend
Featherstone
Langley
Segedunum
Staward
Tyne
COUNTY DURHAM
Ninebanks
Whitley Castle
South
Tyne

Introduction

I was born in Northumberland, near the end of the Roman Wall, and I grew up in a coastal village whose clifftops are crowned with evocative medieval ruins. It is little wonder then that I shared an interest in local history with my father, fuelled by a copy of *The King's England – Northumberland*, which had been presented to my mother when she was a twelve-year-old schoolgirl to commemorate the Queen's Coronation. I read it from cover to cover in my own childhood and took it with me when I moved away from the area to look at when I felt homesick. I still have it on our bookshelf now.

Northumberland has always been on a frontier and is a county of contrasts, with her hillfort territory in the north and her rich Roman heritage in the south. Dramatic castles and pele towers can be found throughout, making it a fascinating area to explore, and there are so many sites that it is impossible to cover them all in a book such as this.

Before the Roman invasion of Britain, there was no Anglo-Scottish border. What is now Southern Scotland and Northern England was then a land of small-scale skirmishes between rival tribes and clans. For hundreds of years subsequently, the position of the border changed repeatedly, either as the cause or the effect of conflicts on a much larger scale. Eventually, however, the Union between England and Scotland rendered the border little more than an administrative line on the map.

In addition to the problems posed by the Scottish border, from the time of the Vikings until the Second World War there existed the constant threat from hostile nations across the North Sea. Northumbrians, therefore, appreciate the county's place geographically and historically, acting as it did for centuries as a buffer zone between Scotland and England, much closer as it is to Edinburgh than to distant Westminster. Two thousand years of uncertainty, turmoil and threat have left a remarkable legacy in the unique landscape of this remote corner of England, combining hilltop Iron Age settlements and the great Roman infrastructure with many centuries' worth of later fortifications of all types and sizes.

Northumberland's ancient hillforts and medieval castles were regular destinations for family outings and school trips for as long as I can remember, and with my two sons I have walked the length of its greatest defensive monument – Hadrian's Wall. I am fortunate that I was able to spend much of my childhood exploring the steep grass banks and ruins of Tynemouth Castle, a place to fire the imagination with its centuries of military history intertwined with a fiery monastic past.

For purposes of this book, 'Northumberland' refers to the historic county as it existed for centuries before 1974, when its populous south-east corner was grafted onto part of County Durham to form the faceless and short-lived political entity of Tyne and Wear.

This book attempts to show some of the variety in Northumberland's rich legacy of defensive structures from prehistory to modern times. I have included a glossary at the back, in order to define some of the less familiar terms. Unless otherwise credited, photographs are by the author.

Thanks to Anne Russell at RAF Boulmer for her assistance, and to Sir Humphry Wakefield of Chillingham Castle for his words of encouragement.

I owe a huge debt of gratitude to the Borders Gliding Club at Milfield for giving me the opportunity for some spectacular aerial photography.

I humbly dedicate this book to my parents, the late John ('Jack') Alexander MBE and Sue, in gratitude for instilling in me my love of Northumberland's wonderful landscape and history.

Chapter 1

Prehistory

There is substantial evidence of our ancient Northumbrian ancestors, who lived thousands of years before the Roman invasion. The remains of what is thought to be Britain's oldest house (so far discovered) were found at the beginning of the twenty-first century on a clifftop at Howick. The circular dwelling is approximately 10,000 years old and was built close to a freshwater stream, as well as the beach.

By the Iron Age, approximately 2,500 years ago, the uplands of Northumberland had become a landscape of hilltop forts, and there is evidence for well over 200 of them in the county.

Captain Armstrong's Northumberland map of 1769 shows ringed hilltops that were 'supposed to be a refuge for the Christians against the Pagans' – by which he meant the Vikings. In fact, they predate the Viking invasions by a considerable amount of time, for Northumberland's hilltop Iron Age forts date from approximately 700 BC to the beginning of the Roman period.

There are hillforts scattered about all over upland Britain but those in Northumberland are smaller and are of different character to those in the south, such as the extensive and well-known Maiden Castle in Dorset. Northumbrian sites range in size from the tiny Middle Dean, covering only half an acre, to the expanse of Yeavering Bell, which covers 14 acres – roughly the size of almost ten football pitches.

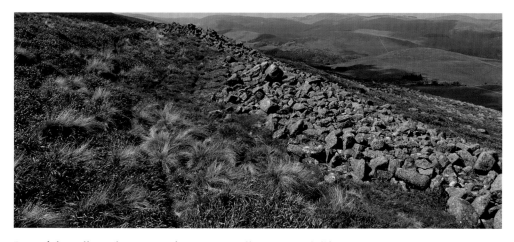

Part of the collapsed rampart of Yeavering Bell's Iron Age hillfort.

Rather enigmatically, Northumbrian hillforts tend to hold less evidence of human occupation than others elsewhere, which raises the question of their purpose.

It had been assumed by some that the Iron Age was a time of constant conflict and that the people lived in their hillforts permanently, with strong ramparts to protect them from attack by neighbouring hillfort tribes. However, some hilltop sites in Northumberland would not have been defensible at all, for although their walls and embankments may have looked impregnable from the front, many would have been vulnerable to attack from the rear. Perhaps they were simply intended as deterrents, or as symbols of status or power.

Two sites in particular demonstrate this. Staw Hill and Mid Hill near Hethpool lie about 650 yards apart, separated by a shallow valley. The southern wall of Staw Hill's fort, facing Mid Hill, is very impressive, but the northern side is lower and much simpler. Is this an indication that our Iron Age ancestors thought that simply *appearing* defensively strong was as important as being defensively effective?

Another factor to cast doubt on the theory that hillforts were permanently inhabited is their lack of convenient water supplies. None of them contain any streams or man-made wells, so the inhabitants could not have lasted long under siege. It may have been possible to collect rainwater from the roofs of the roundhouses, or perhaps water was simply carried up in containers of some kind.

While some experts argue there is no reason why the hillforts should not have been lived in all year round, it is not agreed upon. Perhaps people lived up there in the summer months, when it was warm enough to grow crops and keep livestock, and migrated to the valley bottoms or to the coastal plain in the winter. It is, of course, entirely possible that our ancestors only used the hillforts when they felt threatened. With native brown bears and wolves still extant at the time, it wasn't just from human enemies that the fort-builders sought protection for themselves and their livestock.

Another, further reaching theory is that centuries of agricultural activity have obliterated any archaeological evidence of lower-lying contemporary settlements, and that in fact most Iron Age folk spent the majority of their time in the valleys. It just so happens that most of the archaeological evidence for settlements survives at higher altitudes, and above arable land.

The most common buildings found inside hillforts were roundhouses. The largest of these circular structures could be over 25 feet in height and 50 feet in diameter. They had timber roof frames covered in woven sticks and heather thatch, while the walls were of wattle and daub and would be built to endure the worst upland Northumbrian conditions. Excavations reveal that the roundhouses had a central fireplace and archaeological finds indicate that internal areas were set aside for sleeping and cooking. A replica roundhouse can be seen at the Maelmin Heritage Centre at Milfield.

One of the best known and most accessible hillforts is Lordenshaws, near Rothbury. Its defensive value is questionable as it is completely overlooked by the Simonside Ridge. It has multivallate (multiple walls) ramparts, and nearby there are many good examples of the mysterious 'cup and ring' marks, which are found carved into rocks all over Northumberland's upland areas. These predate the Iron Age and nobody knows for certain their meaning, other than the fact that they must have been significant, possibly spiritually, to their creators.

Further up Coquetdale, and overlooking Hepple, is a good example of a hillfort that used the existing topography to its advantage. Witchy Neuk is protected by man-made

ramparts forming a horseshoe shape on three sides of the fort, but its northern rampart is a straight line along the top of a steep natural escarpment. The ramparts, whose stonework is visible in places, are surrounded by a ditch. A burial cairn and some hut circles were excavated at Witchy Neuk in the 1930s, yielding the first definite evidence of a wooden roundhouse in Northumberland.

To the north of Coquetdale, and in the Cheviots proper, the Ingram Valley is prime hillfort country. Dating from around 150 BC, Brough Law is a short, steep, rewarding climb from the River Breamish, beside Bulby's Wood, and is one of Northumberland's best-known hillforts. The collapsed ramparts give some idea as to how massive its masonry was, and some of the well-built outer faces still stand waist high. It is at the beginning of the waymarked Hillfort Trail, which takes the hiker on a circular route past several other examples. These include Turf Knowe, which was built around a pair of Bronze Age burial cairns. Within the ramparts on Wether Hill, circular grooves delineate the sites of timber roundhouses, while the fort marks the site of prehistoric burials dating back over 4,000 years. Middle Dean has clearly visible ramparts, but like many so-called hillforts it is not on a hilltop. It would, however, have provided its occupants with an unobstructed view down the valley of the Middledean Burn towards Ingram.

The Iron Age ditch and rampart remains at Witchy Neuk Hillfort.

Light snow on the Cheviots, as seen over the stone rampart of Brough Law Hillfort.

About 2 miles upstream from Brough Law, the extensive remains of the fortified Iron Age settlement of Greaves (or Grieves) Ash, covering 20 acres, are hidden away. Tomlinson suggests the name derives from *Gerefa-Folc-Ash* (burnt hamlet of the tributaries), from which he infers that its settlers had in some way incurred the wrath of the Greve (governor) and he burned them out. There are three forts here, each containing several hut circles. Some are as large as 25 feet in diameter, and all are protected by double ramparts of stone. The stone outlines of the hut circles are easily traced.

Further north again there are several notable hillforts above the River Glen and along the College Valley. The largest of these crowns the twin summits of Yeavering Bell, and is thought to have been the principal settlement of the *Votadini* tribe. The staggering quantity of stone that once formed its oval rampart is clearly visible in aerial photographs, and is equally impressive when the beholder stands next to it. Yeavering Bell boasts the remnants of more than 120 roundhouses, of which two are clearly of a much larger size and whose entrances face the main gateway. These were possibly reserved for chieftains.

An Iron Age hut circle within Grieves Ash fortified settlement.

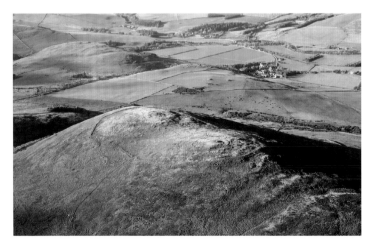

The large hut circle on Yeavering Bell's east summit is visible in this aerial view, which was made possible through the generous assistance of the Borders Gliding Club.

Nearby, and beside the River Glen, is the site of the ancient palace of *Ad Gefrin*, from which King Edwin is said to have ruled his kingdom of Northumbria. More history is evident on the northern slopes of Yeavering Bell, where a battle stone in a field commemorates the 1415 victory of 600 men led by Sir Robert de Umfraville over 4,000 Scots.

Moving up the valley of the College Burn, south of Hethpool, the outer faces of the ramparts of Sinkside Hill's fort demonstrate skilful Iron Age stonework. Indeed, it is recognised as some of the best preserved prehistoric masonry in the country. Shepherds have made use of the fort as a sheepfold in more recent times. Nearby, on the north ridge of Blackhaggs Rigg, the hillfort has the remains of stone walls and takes advantage of the precipitous east slope as a natural defence. At the tiny hamlet of Hethpool with its medieval pele tower is the confluence of the College Burn and its small tributary, the Elsdon Burn. Looking down on Hethpool are the concentric circles of double earthen ramparts forming Ring Chesters (also called Elsdonburn Camp) at an altitude of 1,120 feet.

Hethpool is also overlooked by the twin hillforts of Little and Great Hetha. The former is on the spur of the steep-sided ridge but its stone ramparts have been heavily depleted over the centuries, probably because of its low altitude and close proximity to later valley settlements.

Great Hetha's hillfort offers superb views over the site of a Neolithic stone circle beside the College Burn, so the location possibly had some sacred significance to its

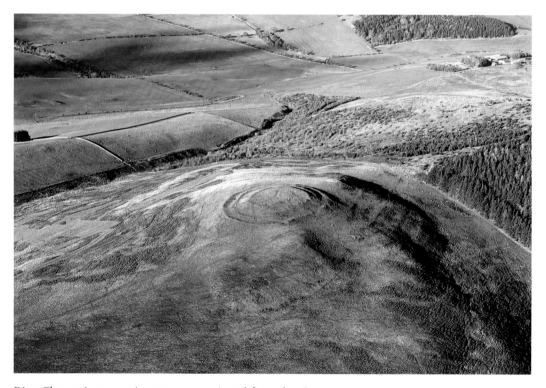

Ring Chesters' concentric ramparts, as viewed from the air.

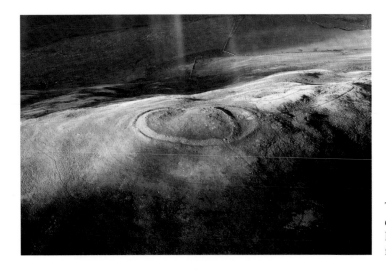

The ramparts and ditch encircling Great Hetha's Iron Age hillfort, as seen from the air.

An attacker's view of the hillfort at Old Bewick.

architects. Great Hetha's earth banks and collapsed stone ramparts are impressive and there are traces of several huts, but perhaps its most unusual feature is the man-made bank of earthwork, which blocks the easiest approach to the enclosure.

East of the main Cheviot range, the hillfort at Old Bewick is sited on a craggy hilltop to the south of Chillingham, and there is a pleasing continuity here for it contains a Second World War pillbox, meaning that, spanning 2,000 years, this location has played two quite different roles in Northumberland's defensive story.

About a mile to the east of Old Bewick, and just south of the picturesque deserted farmstead of Blawearie, the remains of a small fort occupy a steep-sided vantage point above the waterfalls of Harehope Burn – which is probably one of the closest sources of fresh water to any of the Iron Age hillfort sites in the county.

'Ros Castle' is the name given to a prominent hillfort at a 1,000-foot elevation, which offers spectacular panoramic views to the coastal castles and the Cheviots. Its massive

ramparts – doubled in places – are difficult to trace due to the thick covering of heather on the summit plateau. Archaeological evidence has been found that suggests it may have been a site of significance before the Iron Age, and its importance continued well into the medieval age, when the location was used as the site of a beacon.

Visiting any of the hillfort sites in the Northumberland National Park is a rewarding experience that promises solitude while delivering superb scenery and historic interest.

The earth ramparts of the hillfort (top left) tower above the waters of Harehope Burn.

Chapter 2

The Roman Era – Military Order and its Legacy

The next major chronological phase in Northumberland's defensive history is the Roman occupation.

The Roman Conquest of Britain began in AD 43 but it would take another forty years before Emperor Agricola attempted to extend the bounds of the Roman Empire into the Highlands of what is now Scotland. This position could not be held so the northern frontier was fixed in the second century at the narrowest point of England, from the Tyne to the Solway Firth, right through the heartlands of the *Brigantes* people. A road was constructed around AD 100 to connect the fort at *Corstopitum* (Corbridge) with *Luguvalium* (Carlisle). This became known as the Stanegate, and was part of a network of Roman roads that formed the basis of the major routes in the region until the eighteenth century.

The Roman frontier was inspected by Hadrian in AD 121, and to the north of the Stanegate his men built the 73-mile wall that carries his name. The great project also included additional roads, several 'outpost' forts to the north of the wall and 'hinterland' forts to the south.

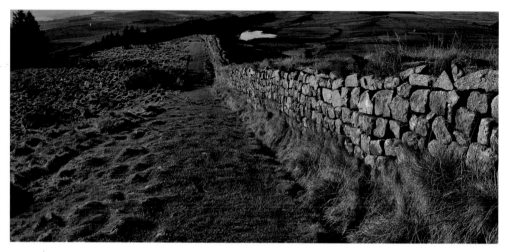

A fine stretch of Hadrian's Wall looking west over Hotbank and Crag Lough.

The Roman governor of Britain, Lollius Urbicus, reclaimed the area between Hadrian's Wall and the Forth–Clyde Line around AD 140. There he established the Antonine Wall, but this was to last no more than twenty-five years, after which its Northumbrian predecessor would once again form the Empire's northern edge. Between AD 205 and 208 Severus reconstructed Hadrian's Wall, which would serve a further two centuries before being abandoned along with the rest of Roman Britain.

Of the 73 miles (80 Roman miles) that formed the route of Hadrian's Wall, about 45 of them are inside Northumberland. This includes most of the best preserved sections, as well as the major surviving forts, milecastles and turrets. The Venerable Bede described the wall in the eighth century as being 12 feet high and 8 feet thick, though it may have been taller. To the indigenous people of second-century Northumberland it must have been a thing of great wonder. Built of regular limestone blocks bonded by lime-based mortar, for a significant portion of its length the Roman engineers also took advantage of the great geological fault named the Whin Sill, constructing several miles of the new frontier on top of the massive north-facing crags. This section is without doubt the most spectacular stretch of the wall today.

The main forts along the wall were about 7 or 8 miles apart, with gates that allowed traffic to pass through. Each fort would house about 1,000 men in their barrack rooms and some provided stabling for cavalry horses. The smaller milecastles, each with its own garrison of perhaps twelve men, were spaced 1 Roman mile apart and protected small gates through the wall. In addition, there were two turrets between each pair of milecastles. Collectively, these structures formed a continuous chain of communication and observation along 80 Roman miles of military zone.

The Romans brought large-scale engineering to Britain, for as well as the more visible structures mentioned above, there were aqueducts to supply the forts, with watercourses following the contours to channel fresh water from higher ground. Many of these can be traced on large-scale Ordnance Survey maps.

The wall was intended to establish order, and not as an act of hostility towards the natives. However, an inscription found in the Tyne at Newcastle records the arrival of reinforcements from Germany in the middle of the second century, suggesting that the time of the Roman occupation was not always a peaceful one. Later that century, the Roman statesman and historian Cassius Dio describes a troublesome war, in which 'tribes' crossed the wall and killed a Roman general and his men. The end of this war was commemorated on Roman coins in the year AD 184.

The Romans withdrew from Britain around AD 410, abandoning their great wall. However, it is thought that the fort at *Banna* (Birdoswald), just over the modern county boundary in Cumbria, may have continued in use, its commander possibly having become a local chieftain.

The remains of the wall were still substantial a thousand years later and it was not until after the Jacobite Rebellion of 1745 that much of it was to disappear. General George Wade was frustrated that his men in Newcastle had been unable to prevent the Pretender's troops from taking Carlisle due to the lack of a good road from east to west. His solution was to demolish much of the wall and use both its stones and foundations to build what is still known as the 'Military Road', the B6318. Yet more of the excellent Roman masonry was robbed over the centuries to construct farm buildings.

Renowned nineteenth-century antiquarians John Clayton and John Collingwood Bruce are responsible for much of the archaeological excavation and cataloguing of the wall,

its forts, milecastles, turrets, other outlying buildings and the *vallum*. Happily, there are many sections of the wall that were avoided by the Military Road and which can be enjoyed today. Indeed, a path now allows the intrepid to walk the entire length of Hadrian's Wall. At various locations there are modern reconstructions of sections of the wall, a fort gatehouse, a bath house, a turret and so on, but their form is conjectural as nobody knows for certain the precise appearance of the upper sections of the original structures. The wall became a World Heritage Site in 1987.

We begin our journey along Hadrian's Wall at Wallsend-on-Tyne. For many years its Roman fort, *Segedunum*, was buried beneath terraced streets built to house the workers of the world-famous Swan Hunter shipyard. It is strange to think that the record-breaking luxury liner *Mauretania* and, later, the iconic 250,000 ton 'supertankers' were built just yards from a Roman fort. In the 1970s the streets were cleared and the excavation of the Roman site began. To the east of the fort a short stretch of wall ran down the bank to the River Tyne, where it terminated.

Segedunum's layout is similar to that of the other forts along the wall; a rectangular form with radiused corners and gates on all four sides. Today's A187 Buddle Street runs across the northern part of the remains, so only about two-thirds of the foundations are visible. A section of the wall running west has been excavated to the north of the modern road, and alongside it is a reconstructed section giving an idea of its original appearance. Back inside the fort is a modern replica of a Roman bath house.

A modern residential road named Fossway marks the approximate route of the wall through the eastern suburbs of Newcastle-upon-Tyne, but hundreds of years of urban development have obliterated most of the evidence of the wall's existence in the Tyneside conurbation. A section was uncovered in 2001 during building work for a new swimming pool on Shields Road in Byker.

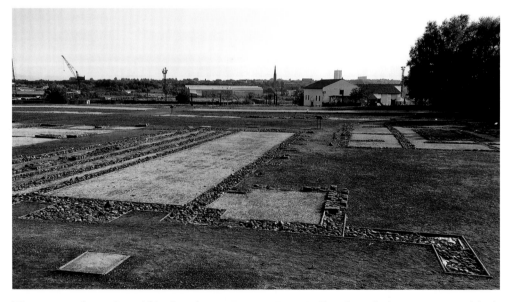

The excavated remains within *Segedunum* Roman Fort (Wallsend) with the reconstructed bath house in the background, to the right of the centre.

Next to the medieval castle keep and beneath the railway arches in Newcastle city centre, stones mark out the positions of the headquarters building, commander's house and granary of *Pons Aelius* – the fort sited to guard the Roman bridge here. Heading west from here, the course of the wall is followed by one of Newcastle's oldest main thoroughfares, Westgate Road, which becomes the West Road and eventually the A69.

Fragments of the Wall, blackened by centuries of Tyneside pollution, appear sporadically as the road heads west, including Denton Hall Turret, but it is at the village of Heddon-on-the-Wall where the first substantial section can be seen. Following the Military Road west from Heddon, any modern traveller will be disappointed initially when looking for Roman masonry, for much of it lies beneath the road surface – buried in the eighteenth century by General Wade's men. There are, however, some impressive and well-preserved stretches of the *vallum* to the south of the road. It is not until Planetrees, 13 miles west of Heddon, that the wall makes a welcome reappearance.

Soon after this a much longer stretch is plain to see at Brunton, where the wall descends into the side of the North Tyne valley. As well as the curtain wall, this section includes a good example of a turret.

The wall continued across the River North Tyne in the form of a bridge just south of Chollerford. The foundation of the eastern bridge abutment, which incorporates a millrace, can be inspected. The bases of some of the piers can be seen when the river is low.

Across the river, the corresponding bridge abutment has been lost to the changing course of the river, but nearby the great fort of *Cilurnum* (Chesters) has the best preserved bath house on the frontier. It is notable not least for some of the tallest remaining masonry along the wall, some of which is still standing at 10 feet high. The wall niches can be seen in what was once the changing room for bathing soldiers. Chesters also has a museum, which houses an extensive collection of archaeological finds from the Roman Wall.

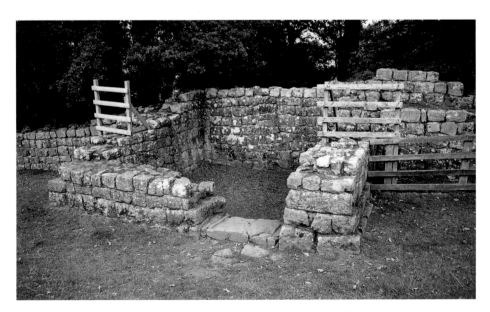

Brunton Turret on Hadrian's Wall, between Chollerford and Wall.

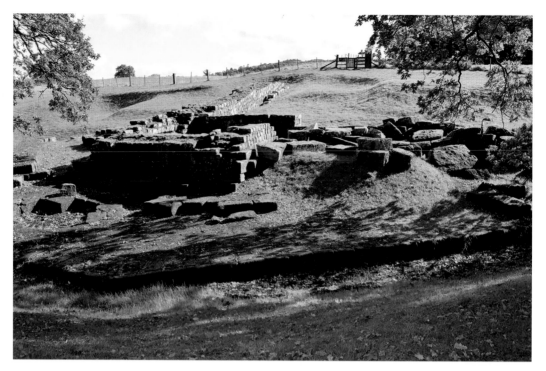

The abutment of the bridge that carried Hadrian's Wall across the North Tyne at Chollerford.

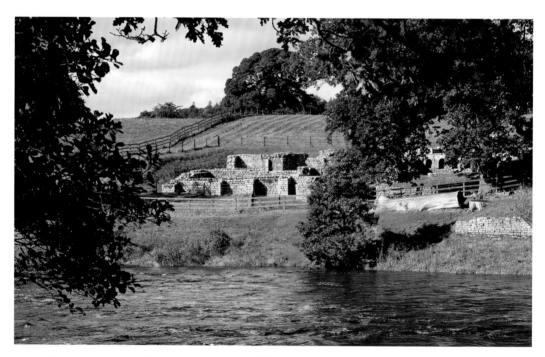

The bath house at *Cilurnum* Roman Fort (Chesters), viewed across the North Tyne.

Beyond Chesters, and once the Military Road has climbed out of the valley, more significant remains of the wall appear, together with a turret at Black Carts. It survives here because General Wade's road runs parallel to Hadrian's frontier at this point, rather than on top of it.

The unexcavated remains of the fort at *Brocolitia* (Carrawburgh) are evidenced by the grass-covered ramparts, and nearby is a small temple that was built by soldiers and dedicated to Mithras. It is close to a spring, named Coventina's Well, where leadminers uncovered approximately 14,000 Roman coins in 1876.

West of Carrawburgh the road deviates completely from the route of the wall, which now climbs to the summit of the dramatic escarpment of Sewingshields Crags, where the remains of Milecastle 35 are found, as are three of the neighbouring turrets.

Descending from the crags at King's Wicket, there is a massive section of the wall where its sheer thickness and strength can be appreciated as it approaches *Vercovicium* (Housesteads). This is the most impressive of all the wall forts, partly because of its spectacular situation on a slope above the Military Road, but also because so much of it is visible.

Housesteads has substantial outer walls, including gateways, and within the fort its granaries, hypocausts, headquarters building, commander's house and even the elaborate soldiers' latrines can be inspected. The south gate of the fort was rebuilt into a bastle house and was used by border reivers, but any post-Roman additions have now been taken down. There are also traces of the *vicus* outside of the fort walls.

West of Housesteads the sheer majesty of the location can be fully appreciated as the wall marches west along a series of precipitous crags past Hotbank and Peel Gap. The sense of isolation here is tangible as the visitor surveys the wilderness that stretches to the north beyond the loughs below.

As well as the wall itself, which rollercoasters its way across this most spectacular tract of Northumberland, a couple of the best examples of milecastles are found here. Milecastle 37, just west of Housesteads, is unique in that the massive masonry blocks of its north gate still include some of the archway, although the gate could have been of little use as it leads to a steep drop.

Substantial Roman masonry at *Vercovicium* (Housesteads).

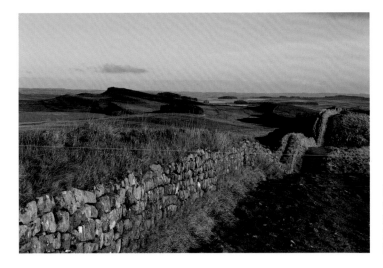

Looking east along the Wall from Hotbank towards Broomlee Lough and Sewingshields Crags.

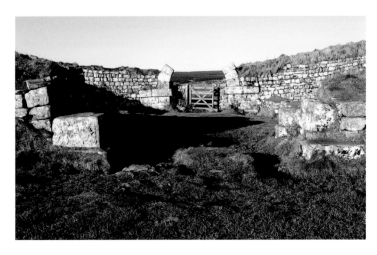

The arched north gate of Milecastle 37 is illuminated in the low winter sun.

Milecastle 39, also known as Castle Nick, seems at first glance to be in an odd location, sited as it is at the bottom of a natural dip among the crags of the Whin Sill. Perhaps the Roman architects decided it was more important to control traffic through the gap than to have a higher vantage point.

At Cawfields, Milecastle 42 is another excellent specimen, and evidence of a Roman water mill was found nearby, illustrating the self-sufficient nature of the military zone.

Although many sections of the wall still exist to the west of Cawfields, along with remains of forts, milecastles and turrets, they tend not to be as impressive as those mentioned above. Generations of farmhouse builders and dry stone wallers have used the rectangular Roman masonry as a ready source of building materials rather than going to the trouble of quarrying their own.

The fort of *Aesica* (Greatchesters) is notable for the survival of its vaulted underground strongroom. Nearby is the Roman Army Museum at the site of the fort of *Carvoran*, just east of Greenhead.

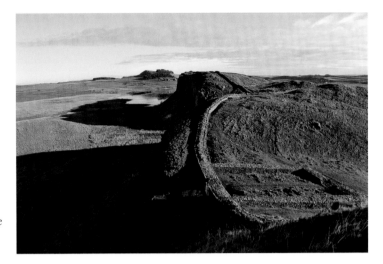

Milecastle 39 with Crag Lough beyond. It is clear to see how the Romans took advantage of the north-facing crags here.

The substantial remains of another milecastle are a matter of yards over the Cumbrian border at Gilsland. This is a remarkable survivor given the proximity of the Newcastle & Carlisle Railway's viaduct, beneath which the course of the wall passes.

As well as the many forts along the wall, there are several Roman outposts to be found to the north, and hinterland forts to the south of the military zone. Hinterland forts include the diamond-shaped Whitley Castle on a hillside near Kirkhaugh in South Tynedale and the great supply station at *Vindolanda* (Chesterholm), near Twice Brewed, where the extensive remains are being excavated on an ongoing basis.

One of the more notable outposts is *Bremenium* (High Rochester), situated on Dere Street, which ran from *Eboracum* (York) into the heart of Scotland. The fort is about 18 miles north of Hadrian's Wall. It predated the wall, existing in the late first century, and Lollius Urbicus, the Roman governor of Britain, stayed here in AD 142 on his way to oversee the building of the Antonine Wall. It became more important after the latter

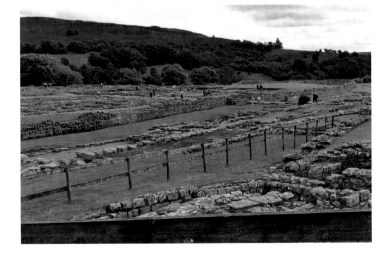

A general view of the ongoing excavations taking place at *Vindolanda* (Chesterholm). (Photograph Clare Jones)

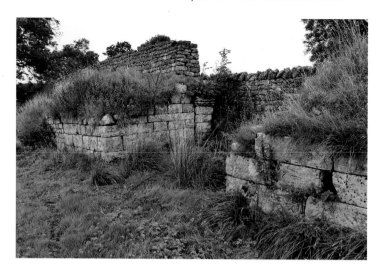

The massive masonry of the west gate of *Bremenium* Roman Fort (High Rochester).

was abandoned. The fort was armed with *ballistae*, the Roman artillery machine, and records have been found here of the storehouses for them. *Bremenium* was strengthened around AD 300 by Emperor Constantius. Today its interior is occupied by farm buildings, but parts of its substantial curtain wall and some of the massive masonry in the gateways can be clearly seen.

Even further north, nestling against the present-day Scottish border, the Roman site at Chew Green can be found at a remote and windswept location in the Cheviots at an elevation of almost 1,500 feet. It was once described as the most complicated and remarkable group of earthworks in the Roman Empire. Squeezed onto the sloping triangular plateau of land above the infant River Coquet are the remains of a large Roman marching fort, two fortlets, two camps and a stretch of Dere Street. The correct Roman name for the fort is not known for certain but it was possibly *Ad Fines*. From the eleventh century the site was overlaid by a village of turf houses named Gamelspath or Kemylpethe, which also featured a chapel and tavern.

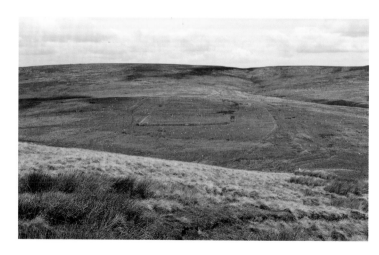

Outlines of several Roman structures, including Dere Street, can be made out in the turf at Chew Green, high in the Cheviots.

Chapter 3

The Great Medieval Castles, and Some of the Smaller Ones

As would be expected from this frontier land, Northumberland contains more castles than any other English county. The story of some of those castles goes back to a time long before the name of Northumberland existed.

The mighty kingdom of Bernicia had been born through a series of wars and strategic marriages. This realm included what would later become the English counties of Northumberland and Cumberland along with the Scottish regions of Lothian and Galloway. In the year AD 547 the Angles invaded with King Ida seizing Bamburgh. By the eighth century, a fragile union had been formed between the rulers of Bernicia and Deira, and at the time of the Venerable Bede this 'united kingdom' of Northumbria was a dominant force in Pre-Conquest Britain. Culture and religion flourished in the region as Viking invaders began to arrive in the late eighth and early ninth centuries; but unlike the north-west of England, there would be no extensive Viking settlement in the north-east.

Northumbria, the kingdom that stretched from the Humber to the Forth and included part of Lancashire, was governed from massive castles, with her capital at the mighty fortress of Bamburgh on the Northumberland coast.

Bamburgh was described by Sir Walter Scott in *Marmion* as 'King Ida's castle huge and square'. Like many Northumbrian defences, the castle uses the landscape, being sited on a huge natural rocky outcrop of 5 acres. Visitors to this Northumbrian beauty spot cannot fail to be impressed by Bamburgh Castle as it towers over the picture-postcard village on one side and unspoilt sand dunes on the other.

Ethelfrith the Destroyer, grandson of Ida, gave the settlement to his wife, Bebba, and it was renamed Bebbanburgh after her. Despite being set on fire by Penda of Mercia in the seventh century, Bamburgh, as it became, continued as the capital until AD 993, when it was raided by the Danes. The site was then chosen by William the Conqueror for a wooden fortress for his governors of Northumberland.

In 1095, Robert Mowbray, the rebellious Earl of Northumberland, found himself besieged at Bamburgh by William Rufus, son of the Conqueror, who built a wooden 'siege engine' nicknamed the *Malvoisin* (bad neighbour). Mowbray managed to escape

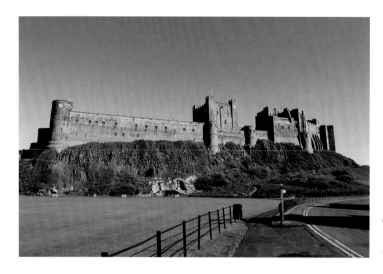

The magnificent Bamburgh Castle, viewed from the village.

to the sanctuary of Tynemouth Priory but could not escape eventual capture. He was forced to surrender Bamburgh under the dreadful threat of having his eyes gouged out.

Late in the Norman period, Henry II began rebuilding Bamburgh in stone to withstand Scottish attacks. The castle was visited by King John and it later witnessed Edward III signing a treaty with Scotland, in which much Scottish territory became English. During the Wars of the Roses, Bamburgh Castle saw some of the most significant action of any Northumbrian stronghold. Following the Battle of Towton in Yorkshire, the castles of Bamburgh, Alnwick and Dunstanburgh were in Lancastrian hands, with support from their Scottish allies.

By the spring of 1462, however, the Earl of Warwick had negotiated a truce with Scotland, giving him an opportunity to recapture the Northumbrian castles, and Bamburgh was won in July of that year. This was a short-lived occupation as Queen Margaret, returning from France where she had been gathering support, landed near Bamburgh in October with French troops led by Pierre de Bréze. The Yorkist garrison of Bamburgh surrendered, but when Margaret learned that Edward IV was heading north with his troops, she escaped across the border.

Henry Beaufort, the Duke of Somerset, and Sir Ralph Percy tried to defend Bamburgh, but they were unprepared and had to surrender after a short siege in December 1462. Somerset and Percy both swore allegiance to the Crown, and Percy became commander of both Bamburgh and Dunstanburgh. This was a strategic move on the part of King Edward IV, who knew that the majority of Northumbrians were fiercely loyal to the Percys, and that awarding this status to Percy would be popular.

In March 1463, however, Percy changed his allegiance, surrendering Bamburgh and Dunstanburgh to Margaret. Some months later, Somerset followed Percy in changing sides, joining the deposed Henry VI at Bamburgh. By the spring of 1464, Somerset's modest army had established control over much of Northumberland, so Edward once again prepared to come north.

While his counterparts at Alnwick and Dunstanburgh agreed to surrender their garrisons to the Earl of Warwick following the Lancastrian defeat at Hexham, Sir Ralph Grey, Bamburgh's commander, held out.

On 25 June 1464, Warwick's men laid siege to Bamburgh. The garrison was offered terms, except for Grey and Sir Humphrey Neville. The terms were refused so Warwick issued a bloodcurdling threat to Grey. He knew that the king wanted the castle intact because of its strategic importance; thus, if Warwick was forced to use gunfire, he threatened to execute a member of the garrison for every shot fired.

The inevitable bombardment started with simultaneous fire from all of Warwick's guns, causing major damage to the walls. It is said that collapsing masonry struck Sir Ralph Grey and it was left to his second-in-command to surrender to Warwick. Despite his earlier threat, the garrison was spared, but Grey was not so fortunate. He was deemed untrustworthy, having changed sides so many times, and in July he lost his head.

The Yorkist victory at Bamburgh effectively marked the end of the Lancastrian campaign in Northumberland. It was also the first time that an English castle had succumbed to gunpowder artillery and the cannon fire it received left it in a state of ruin.

Today's visitors to the castle will see much of the restoration work that was carried out by Lord Armstrong of Cragside, along with lofty Norman walls containing St Oswald's Gate at their northern end. The man-made arches and walls of the gate are built around a natural gap in the rock. Visitors enter the castle through a later gateway at the south-east corner, and on ascending the approach road are met with the sight of the massive Norman keep, each of its square red sandstone walls up to 10 feet thick.

In the early tenth century, the kings of Wessex were being accepted as the first kings of all England, which at that time included southern Scotland up to the Forth–Clyde isthmus. In 1016 the Anglo-Scottish border was redrawn to run through Stainmore in the Pennines up to the River Tweed. King Edmund II had granted Strathclyde, which included Cumberland, to the Scots in AD 945, and Lothian would follow after the Battle of Carham in north Northumberland.

The ancient St Oswald's Gate at the north-west corner of Bamburgh Castle.

The outer gatehouse at the south-east corner of Bamburgh Castle.

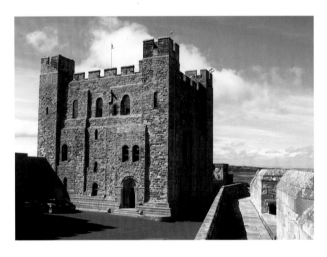

Bamburgh's massive square castle keep.

The Scottish kings wanted to push the border further south and, like the Angles had done before them, they began to marry into the families of Northumbrian nobility. In 1092 William II, son of the Norman Conqueror, took Scottish-held Carlisle and the border moved north again. Unlike the Romans, the Normans did not attempt to maintain a linear border, but exercised control through strategically placed castles and mounted cavalry. Their earliest castles were simple mottes, and through them they controlled land as well as movement along major north–south routes. An example of such a castle is at Elsdon, overlooking Dere Street.

Dominating the 'capital of Redesdale', Elsdon's steeply sided motte and bailey castle towers over Elsdon Burn. The south mound is almost 50 feet high and once held a wooden tower. Though this is long gone, there are traces of later masonry, and it is still possible to view the massive earth ramparts and ditches. It is likely that the castle was erected around 1080 by Robert de Umfraville, and it was the predecessor of the family seat of Harbottle Castle. A stone with a Roman inscription was found on the motte at Elsdon, possibly from *Bremenium* (High Rochester).

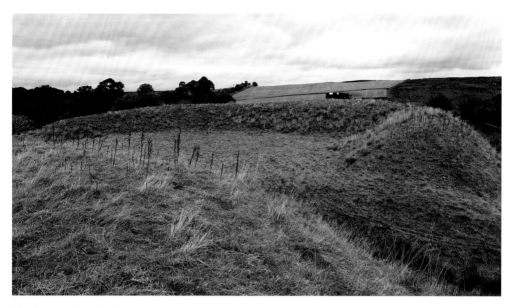

The bailey of Elsdon's castle, as seen from the motte.

During the reign of King Stephen of England, David I of Scotland invaded the north of England in support of Matilda, Stephen's rival to the throne. David was defeated near Northallerton in Yorkshire in 1139, but Stephen still handed over control to Scotland of a huge area to the north of a line drawn from the Tees in the east to the Ribble in the west. David held court at Newcastle and Carlisle, but a stronger English government under Matilda's son, Henry II, pressurised Scotland to return the territory to England and, in 1157, Malcolm IV did so.

During the reign of Henry II, England's position was consolidated when the wooden castles of Carlisle, Norham, Bamburgh, Newcastle and Prudhoe were rebuilt in stone, each featuring a massive keep as its principal structure. Malcolm's successor William I 'The Lion' of Scotland invaded Northumberland, but was captured at Alnwick in 1173.

Norham Castle is situated above an ancient ford across the River Tweed, on the other side of which lies Scotland. It was the stronghold of the powerful Bishops of Durham in their border territory of Norhamshire. Bishop Ranulph Flambard built the first timber castle here in 1121. This was taken twice by the Scots during the invasions that culminated in the Battle of Northallerton. Once Henry II had reconquered this northernmost corner of England, he set about upgrading its defences, and that included Norham Castle, whose solid stone keep was set up by Bishop Hugh de Puiset, nephew of King Stephen and founder of the Galilee Chapel in Durham Cathedral. The architect of Norham's keep was Richard of Wolviston. When it was completed, the castle was confiscated from the Bishops by Henry II. In 1209, Norham Castle saw William the Lion of Scotland paying homage to King John.

Alexander II of Scotland laid siege to Norham for forty days in 1215 but was ultimately unsuccessful. Sir Thomas Grey's garrison was besieged here by Robert the Bruce in 1318 for almost a year, but yet again the Scots failed to take control of the castle.

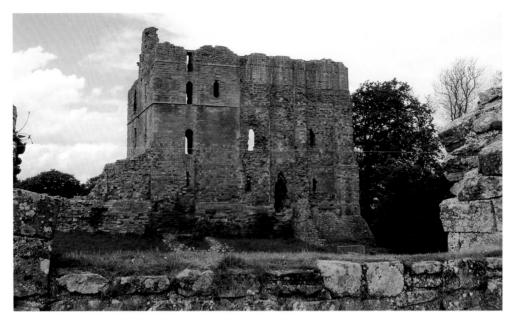

The ruins of Norham's castle keep, viewed across the outer ward.

In June 1463 Norham witnessed one of the most high-profile Scottish incursions of the Wars of the Roses. Scotland at that time was ruled by Queen Mary of Gueldres, widow of James II and mother of twelve-year-old James III. The Scots were in alliance with the Lancastrians, led by Queen Margaret, whose army was also bolstered by French troops under Pierre de Brézé. This joint force besieged Norham Castle, but the assault would end eighteen days later with an embarrassing withdrawal when the Earl of Warwick and his brother Lord Montagu appeared with their Yorkist relief army.

In 1513 the castle took a battering from Scottish heavy artillery en route to their downfall at Flodden, but there remains much to be seen by the modern visitor. The impressive remains of the curtain wall enclose a large bailey, or outer ward, inside of which is the proud ruin of the solid keep. Among the various peripheral buildings, Marmion's Gate stands guard, facing the village on the west side.

Just 10 miles or so upstream from Norham is the village of Wark-on-Tweed. Just over a century after the battle of Wark, Walter d'Espec built his castle there, forming its motte from a naturally occurring 60-foot-high drift gravel ridge known as the Kaim. This mound is all that remains of the once-great border fortress, which was besieged by the Scots eleven times between 1136 and 1523. It was from Wark that Edward I launched his army into Scotland and, later, Edward II assembled his men here in preparation for Bannockburn.

Moving from Tweed to Tyne, in 1080 Robert Curthose, eldest son of William the Conqueror, established a castle on the site of the Roman fort of *Pons Aelius* in the settlement of Monkchester. Newcastle-upon-Tyne had gained its modern name. The Roman fort had been named after the bridge built in AD 120 over the Tyne and the Norman castle was built to guard this, the lowest crossing point on this strategically vital river.

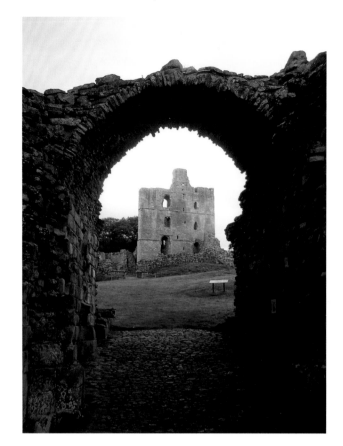

Right: Norham Castle, as seen from the gatehouse.

Below: The Castle Keep and St Nicholas Cathedral crown the skyline above Newcastle's Quayside.

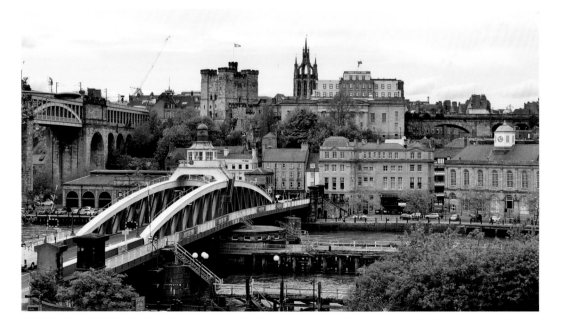

The Roman structure was replaced by a picturesque medieval bridge, with houses and shops along its length, as well as a chapel and a prison, and, like that at Warkworth, featured a fortified gatehouse. Most of the venerable old bridge was swept away in the great flood of 1771 and its position is now occupied by the Swing Bridge of 1876. Curthose's stronghold, which looked down on the bridge, was likely to have been a timber motte and bailey. It is difficult to imagine the loftiness of the site today, due to modern infill around the once-prominent hill.

During the reign of Henry II, around 1168, Curthose's 'new castle' was rebuilt at a cost of £1,144. It consisted of the familiar pattern of a curtain wall with gatehouse and the central keep. The architect of the latter was Maurice the Engineer, who would design the similar Dover Castle ten years later. In places, the walls of the keep are an impregnable 18 feet thick, and its entrance is on the second floor up a steep flight of steps, which is guarded by an outer building.

An aisled great hall was added during King John's reign and Henry III added the Black Gate in 1247 to strengthen and modernise the castle. Once the town wall was built, the castle diminished in importance, and by 1589 it was described as ruinous.

It suddenly regained significance in 1644 when the Mayor of Newcastle, Sir John Marley, held out here for two days when a Scottish force prevailed following a ten-week siege of the town walls. One story tells that when the Scots threatened the beautiful lantern tower of St Nicholas Church with cannon fire, Marley put his Scottish prisoners up there as a human shield. The church survived to become Newcastle's cathedral.

The castle, meanwhile, ceased to be a military site in 1819 and its dungeons held their last prisoner in 1828.

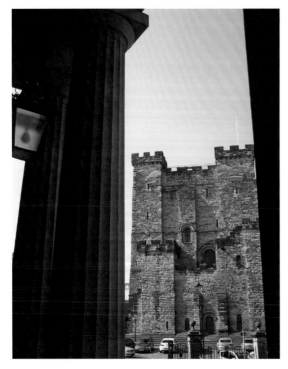

Newcastle's Castle Keep, viewed from the steps of the Moot Hall.

The keep is well worth a visit, not only for the panoramic views from its roof but also for its fascinating interior which includes a beautiful Norman chapel with zigzag ornamentation, contained within the ground floor. It has its own water supply in the form of a 100-foot-deep well.

The Norman keep is a remarkable survivor and has stood sentinel over what was once known as 'the largest railway crossing in the world' since the railway sliced through the castle in the 1840s. A surviving section of the curtain wall and south postern gate, the only Norman example left in England, can be seen at the head of the castle stairs, which descend steeply to the Quayside.

The Black Gate, supposedly taking its name from Patrick Black, a seventeenth-century tenant, is now separated from the keep by the railway line to Edinburgh. Behind it is the Heron Pit, a 12-foot-deep dungeon accessed by a trapdoor. This structure was named after William Heron of Ford, who was the castle's governor from 1247–57. The Black Gate has recently been reopened to the public.

Contemporary with Newcastle's great fortress is Prudhoe Castle, and like Curthose's citadel it is also built on a steep slope above the Tyne. A wide moat protected Prudhoe's south and west sides. It was built by the nobleman Odinel de Umfraville and, like many others of its time, it replaced an existing timber structure.

The massive outer curtain wall surrounds a surprisingly compact inner bailey, inside of which is the ruined twelfth-century keep – one of the smallest in England in terms of 'footprint', although it rises to 65 feet in height and has walls that are 10 feet thick. The foundations of the great hall can also be seen. There is an impressive outer barbican and gatehouse, which contains a chapel on its first floor. William the Lion of Scotland had

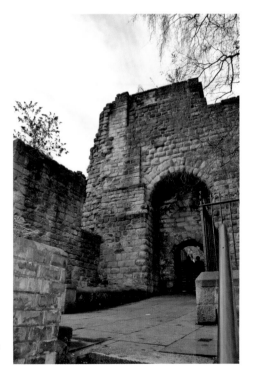

The postern gate of Newcastle-upon-Tyne, at the top of Castle Stairs.

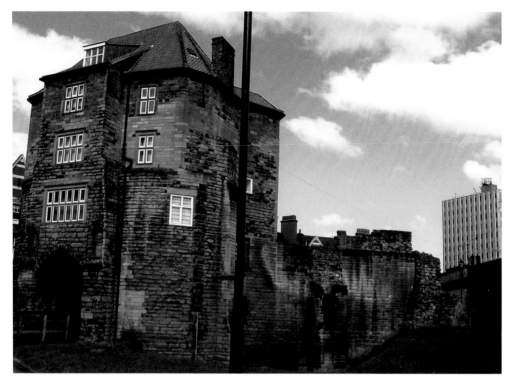

The Black Gate, Newcastle-upon-Tyne, separated from the keep by the railway viaduct (right).

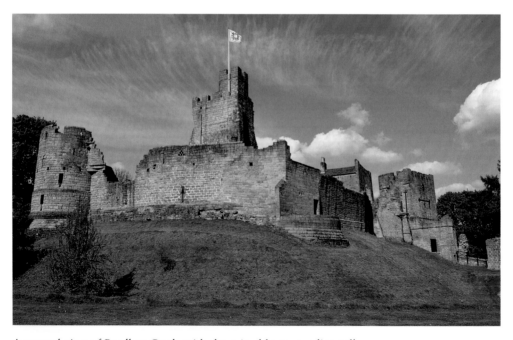

A general view of Prudhoe Castle with the ruined keep standing tall.

Right: The outer barbican of Prudhoe Castle, as seen from the gatehouse.

Below: Prudhoe Castle's gatehouse, with the chapel above the archway.

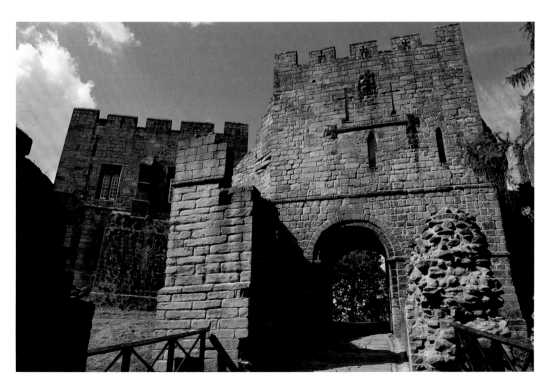

determined to destroy Prudhoe in 1173 but he gave up after three days, and it remains the only Northumberland castle to resist the Scots.

These great new castles presided over a period of relative peace and prosperity for the region, during which time Berwick-upon-Tweed developed into one of the richest burghs in Scotland.

Dating from the twelfth century, the castle at Berwick-upon-Tweed was built with strong outer walls and contained royal apartments, a great hall and a chapel. In an even greater act of Victorian vandalism than that perpetrated at Newcastle, Berwick Castle was virtually wiped out by the coming of the railway in the 1840s. The station platform occupies the site of the great hall. The west wall beside the station and the White Wall descending the steep bank of the Tweed by the Royal Border Bridge are the principal remains of this once-important border fortress. The eagle-eyed visitor may also spot the lower courses of the Constable Tower at the south-east corner of the station site.

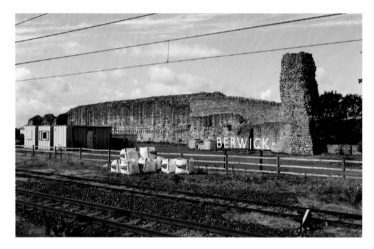

The surviving section of Berwick Castle's curtain wall, as seen from the railway station.

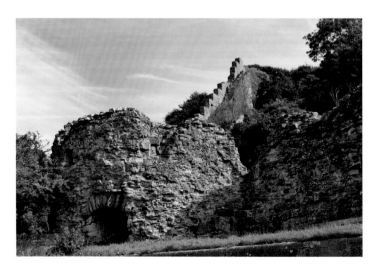

The White Wall of Berwick Castle, viewed from the shore of the River Tweed.

The death of Scotland's seven-year-old Queen Margaret in 1290 led to an acrimoniously disputed succession, of which Edward I of England took advantage and imposed his rule on Scotland through his 'vassal' King of Scotland, John Balliol. Edward then took over directly, removing traditional monarchic regalia and the Stone of Scone. Any accord that had previously existed between the two nations became pure hostility that would last for three centuries, with the people of Northumberland being caught in the middle.

Outright war broke out in 1296, when Edward took Berwick by force and slaughtered many of its innocent citizens, replacing them with English traders. He rebuilt the town's castle and erected its town wall.

Despite his bloody success in Berwick, Edward was unable to subdue Scotland through military action; neither would the Scots accept any kind of political settlement, perhaps because of the Edward's massacre by the Tweed – an event that possibly sowed the seed of what would become Scotland's fierce national identity. This patriotism was an attribute that was exploited by William Wallace in 1297 when he defeated the English at Stirling Bridge and retook Berwick for the Scots. A year later, Edward marched north and won the Battle of Falkirk. Despite this, the simple logistics of distance and trying to cover such a large area as Scotland made English rule impossible; a situation that was compounded by the weakness of Edward I's successor, Edward II.

In contrast to the feeble English monarch, north of the border the Scots had found themselves a strong leader in the shape of Robert the Bruce, following Wallace's execution in 1305. Bruce was able to recapture many strongholds previously taken by the English and he besieged Berwick in 1312. Two years later he defeated Edward II at Bannockburn and the victorious Scots penetrated deep into the north of England, forcing people to buy 'protection' or face burning and looting. Bruce's men used the ancient Roman routes for their incursions, which meant that the more remote upland settlements escaped relatively unscathed, and Berwick finally fell to Bruce in 1318.

The Treaty of Edinburgh in 1328 recognised Scotland's independence but the resulting peace was short-lived. David II of Scotland, son of Robert the Bruce, was ousted by puppet king Edward Balliol, who had been placed on the Scottish throne by dispossessed English lords in 1332. That same year saw an English victory at the Battle of Dupplin Moor, near Perth, and another in 1333 at Halidon Hill, just outside Berwick.

During Balliol's brief reign, much of southern Scotland was handed over to Edward III of England in a treaty signed at Bamburgh. The border now ran from the River Cree, west of Kirkcudbright, to the Avon, near Falkirk, and Berwick was established as the administrative capital of English-occupied Scotland. From 1337 Edward's troops were engaged in a war against France, which allowed Scotland to recover much of her lost territory, while helping their French allies at the same time by keeping Edward's men busy in the north. By 1357 the English invaders had been driven back to the present-day border, with only a few castles to its north holding out. Berwick-upon-Tweed also remained English, despite being on the Scottish side of the River Tweed, which formed much of the border.

Berwick was retaken by the Scots in 1355, 1384, 1405 and 1461, and was finally, permanently claimed by the English in 1482, by which time the old town and her beleaguered citizens had changed hands between the two nations thirteen times in the 335 years since 1147.

Near the end of the War of the Roses, Margaret of Anjou used some Scottish and Northumbrian castles, such as Dunstanburgh, as Lancastrian bases, but with the arrival of a settled government under Yorkist rule and the early Tudors, the north came under central control with Henry VII seeking a settlement with James IV of Scotland. In 1502 the two nations signed another peace treaty and James married Henry's daughter, Margaret. This marriage would eventually lead to James VI of Scotland giving his title to the English throne in 1603.

Dunstanburgh Castle is another dramatic coastal fortress whose walls enclose a windswept expanse of 10 ten acres on a prominent basalt headland. Archaeological finds indicate that there has been human habitation here since at least the second century but the castle, built by Thomas, the Earl of Lancaster and High Steward of England, dates from about 1313. Lancaster was a great opponent of Edward II and his castle at Dunstanburgh may have been a straightforward act of defiance rather than serving any strategic purpose. Edward's reaction to Lancaster's opposition was to have him executed for treason in 1322.

Dunstanburgh would pass into the hands of John of Gaunt, who turned it into the military stronghold we see now. He improved its defences to guard against Scottish attack by rebuilding the two cylindrical towers of the gatehouse into a keep. It is a surprise to discover, on passing between the towers, a straight vertical wall at their rear.

John of Gaunt's strengthening of the castle would ultimately make little difference, as during the Wars of the Roses Dunstanburgh was besieged and taken by the Yorkists. By Tudor times it had fallen into ruin, and a very picturesque ruin it is, attracting artists such as J. M. W. Turner. As well as the distinctive, soaring circular towers, there is the isolated Lilburn Tower to the north-west and a very impressive stretch of curtain wall,

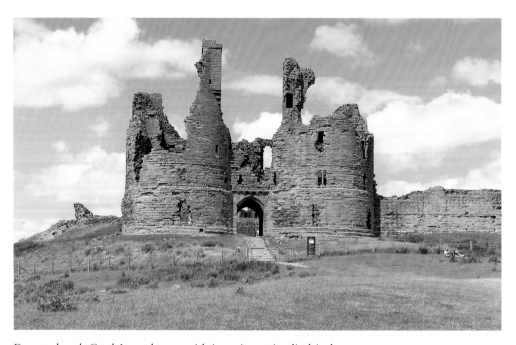

Dunstanburgh Castle's gatehouse, with its twin semi-cylindrical towers.

Right: The top of Dunstanburgh's gatehouse provides a breathtaking view of the curtain wall and the North Sea beyond.

Below: The shattered remains of the gatehouse towers at Dunstanburgh.

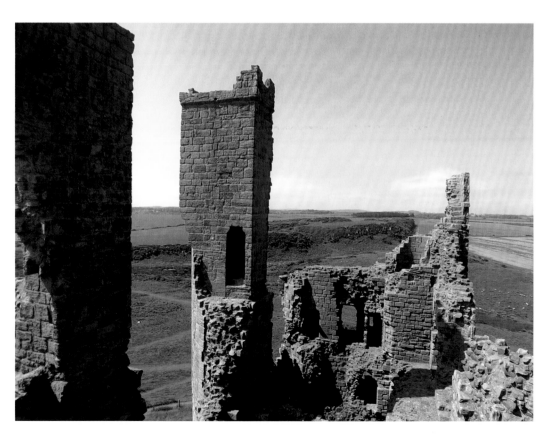

which can be appreciated from the top of the gatehouse. The castle had its own harbour, which was once used as an escape route by Queen Margaret and later to accommodate Henry VIII's fleet. Since blocked by fallen rocks, it is difficult to imagine such a commodious harbour nowadays. Like many sites in Northumberland, Dunstanburgh is now in the care of English Heritage.

One of the earliest Northumbrian castles where masonry remains can be found is Mitford. It is likely that work began sometime around 1070 on the original earthwork fortification. By 1138, when it came under Scottish attack, Mitford was described as the *oppidum* (fortified town) of William Bertram, founder of Brinkburn Priory. In its first two centuries it was a regular target for hostile attacks. In 1215 the castle was taken by the Flemish troops of King John, who confiscated the barony of Mitford from Roger Bartram and handed it to that staunch supporter of the unpopular king, Hugh de Balliol. In the following year the castle was besieged by King Alexander II of Scotland but its garrison under Philip de Ulecote, Forester of Northumberland and another favourite of King John, stood firm.

A hundred years later, Mitford had become the notorious outlaw lair of Sir Gilbert de Middleton, who lived on ransom money from kidnapping. Their occupation was short-lived as the castle was captured in December 1317 by the men of Sir William Felton and Sir Thomas Heton. In the following month, Sir Gilbert and his brother, John, were put to death in London by hanging and drawing in the presence of the cardinals who had been among the victims of the Middletons' thieving ways.

Most of Mitford Castle was destroyed by King Alexander III of Scotland in 1318 and nine years later it was described as 'wholly burned'. It is doubtful if it was ever inhabited again. The shattered remnants of its circular keep are built upon a series of vaulted arches that are built into an artificial mound. It was once surrounded by a massive curtain wall, of which some sizeable fragments remain.

The gloriously restored castle at Alnwick started life as a Norman fortress to guard against devastating Scottish raids. It was begun by Ivo de Vesci, Baron of Alnwick, and completed by Eustace Fitzjohn in the early twelfth century. During Alnwick's first two

The romantic ruins of Mitford Castle.

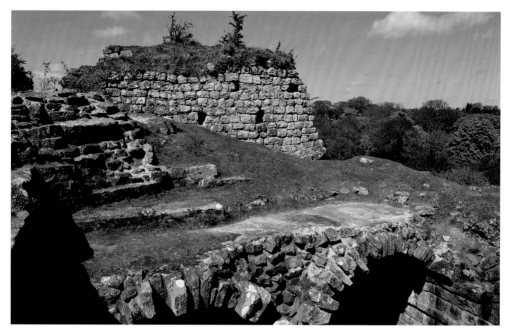

Vaulted masonry beneath the keep at Mitford.

centuries it was repeatedly attacked by the Scots until it was taken over in 1309 by Henry, the first Lord Percy, whose famous Northumberland dynasty was descended from a chieftain of William the Conqueror.

Like Newcastle, Alnwick became a base for military operations against the Scots, being garrisoned by 3,000 troops. Henry Percy greatly strengthened Alnwick's walls and they were able to withstand a Scottish assault in 1327. The fourteenth-century barbican on the west side facing Bailiffgate was once protected by a moat, and is now surmounted by curious eighteenth-century statues, sculpted by James Johnson of Stamfordham, to represent soldiers repelling attack.

In the peaceful eighteenth century, the 5-acre medieval fortress was transformed into the beautiful stately home it is now. This work was carried out by the first Duke of Northumberland and it remains the second largest inhabited castle in England, after Windsor.

Despite the area covered by Alnwick Castle, it is relatively low-lying and largely invisible from the town's main street. The same cannot be said of nearby Warkworth, where the castle dominates the wide main street of the village and is a landmark visible from miles away. The first castle is thought to have been established by Henry, son of David I of Scotland, after the former became Earl of Northumberland in 1139. The curtain wall that stands today dates from about 1200, by which time the castle was in the hands of the Fitzroger family. The Fitzroger line died out in 1332 and the castle was granted to Henry, the second Earl Percy. For two centuries the earls chose to live here rather than Alnwick, which was then more military fortress than house. The third Earl Percy plotted at Warkworth with his son Harry Hotspur to put Henry IV on the throne, and much of Shakespeare's eponymous play is set here.

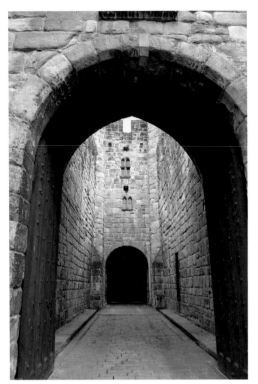

Left: Looking through the barbican at Alnwick Castle, towards the inner gatehouse.

Below: James Johnson's eighteenth-century figures adorn the barbican of Alnwick Castle.

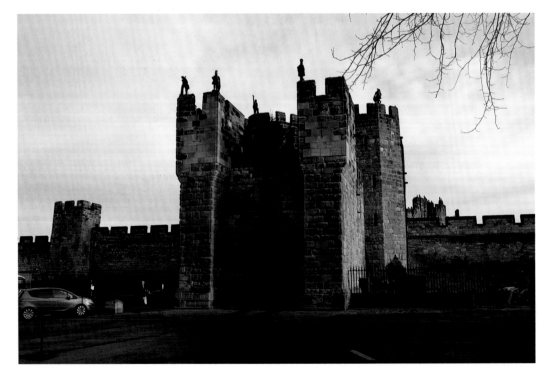

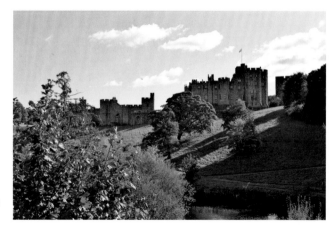

Alnwick Castle above the banks of the River Aln.

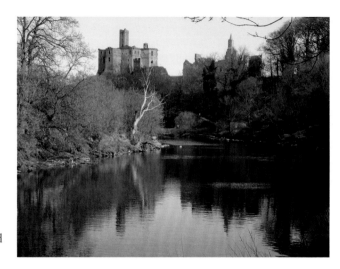

Warkworth Castle stands proud over the wooded River Coquet.

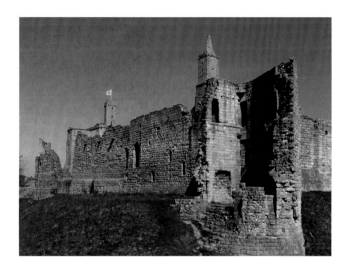

The early thirteenth-century walls of Warkworth Castle.

The castle is advantageously sited on the steep slopes of a naturally defensible, three-sided promontory above the River Coquet, with a man-made ditch to the south. This is in front of the impressive south wall with its central gatehouse, which was once reached by a drawbridge. Warkworth was possibly the first castle in the north of England to make use of projecting towers on the corners and in the centres of its curtain walls – an idea originating in the Middle East and designed to allow its defenders to fire along the walls at any attackers. There are corbels at the top of the massive gatehouse tower, which once supported a stone platform from where defenders could drop missiles on the enemy.

Warkworth Castle's most distinctive feature is its keep, the solid square edifice built on the original motte on the site of an earlier tower. It is distinguished by having a semi-octagonal turret projecting centrally from each of its walls and a tall, slender lookout tower on its roof. The lion's head carving over the doorway of the ruined great hall gives some idea of how ornate this building must have been in its heyday.

At the bottom of Warkworth's picturesque main street, which slopes down from the castle, is the fourteenth-century bridge over the Coquet. This is unusual in that it has a gatehouse at its southern end – a rare surviving example of a fortified river crossing. It was by no means the only defended bridge in the county, for the medieval Haydon Bridge was barred and chained to defend the crossing of the South Tyne against Scottish raiders. This bridge had to be rebuilt in the eighteenth century after the great flood of 1771.

At about the same time as Warkworth was under construction, Odinel de Umfraville, builder of Prudhoe Castle, was commanded by Henry II and the Bishop of Durham to build a stone castle at Harbottle. Being on the edge of the Cheviots, it would strengthen Henry's border defences and stand as a clear demonstration of power. It was once the most remote outpost in the border region and stands on a high eminence above the village. The Scots saw its construction as a challenge to them and they took the castle by force in 1174. They lost it a year later when King William of Scotland was captured at Alnwick Castle. Following this Scottish incursion, the castle was rebuilt more strongly, allowing its defenders to hold firm when Harbottle was besieged again.

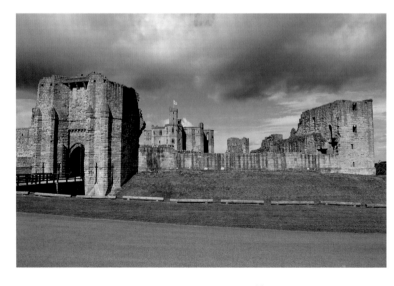

The south wall
and gatehouse of
Warkworth Castle.

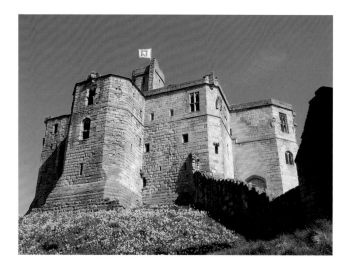

Warkworth Castle's distinctive keep.

The gatehouse on Warkworth's medieval fortified bridge.

Despite being partly destroyed after Bannockburn, by the sixteenth century Harbottle was a key element in the defence of the kingdom. Border warfare in the valleys of Coquetdale and Redesdale was on the increase, aggravated by one Thomas Dacre. Appointed Warden by Henry VIII in 1509, Dacre was supposed to be the governor of the area but he instead stirred up an age of reiving, which would continue well beyond the Union of the Crowns in 1603. Harbottle Castle was under the command of the Keeper of Redesdale, who was said to feel safer there than among his own wild dalesfolk.

In 1515 Harbottle was rebuilt to accommodate Margaret Tudor, widow of James IV of Scotland and sister of Henry VIII, where she gave birth to a daughter also named Margaret. The infant would become mother-in-law to Mary Queen of Scots and grandmother of James VI of Scotland, later James I of the United Kingdom of England and Scotland.

Following the Union, Harbottle was redundant, and when the castle fell into disrepair some of its stone was reused to build the seventeenth-century version, which is a

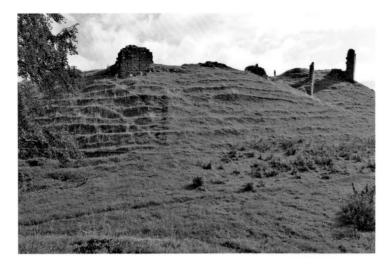

The stark ruins of
Harbottle Castle, high
above the village.

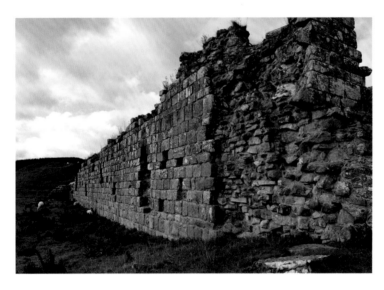

The sturdy masonry of
Harbottle Castle's east
curtain wall.

dignified house more suitable for peaceful times. All that remains of its once-proud keep
are some large sections of masonry, but there is an impressive stretch of curtain wall
still standing on its east side. Two of the gun loops that were installed when Henry VIII
took control of the castle and turned it into an artillery fortress in 1546 can be seen on
either side of a remaining angle of the keep.

In contrast to Harbottle's wild and romantic ruin, Chillingham Castle, the ancestral
home of the Earls of Tankerville, is very much complete, and is the best example
in Northumberland of a courtyard and corner-turret house. It evolved from a
twelfth-century stronghold and received its licence to crenellate in 1344, by which time
the castle had survived several sieges. Chillingham was a favourite of royalty, hosting
Henry III in 1245 and Edward I in 1298. Much later, Charles I and even Edward VIII
were notable visitors.

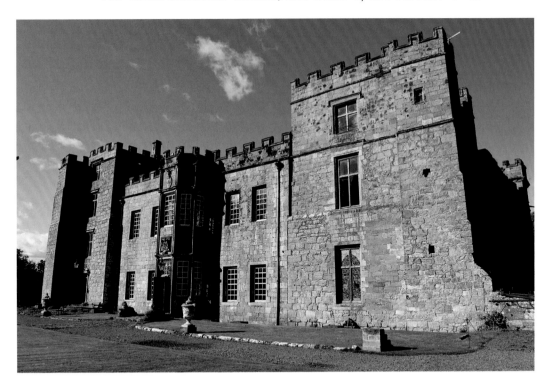

Above: The south range of Chillingham Castle.

Right: Chillingham Castle's courtyard, viewed from the doorway to the hall.

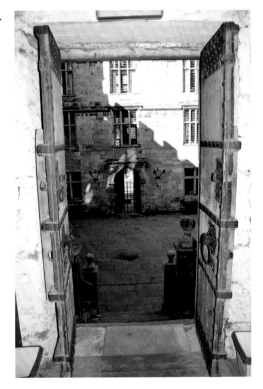

The castle has been largely unaltered since pre-Tudor times, although, prior to the stay of Scotland's James VI on his journey south to become James I of England and Scotland, the impressive galleries were added.

When the land was enclosed in the thirteenth century to build the castle, the famous Chillingham wild cattle were effectively corralled inside. Unlike elsewhere in the border country, thieves would have been unable to steal the cattle because they were too wild to be driven away. Chillingham Castle is a charming and rewarding place to visit, with several staircases leading to fascinating rooms that are packed with artefacts.

In 1287 Ford Castle was the home of Odinel de Ford, whose daughter was married to Sir William Heron, High Sheriff of Northumberland. Following the English victory at Bannockburn in 1314, much of the border country suffered retaliatory Scottish raids. This situation prompted the Heron family to request a licence to crenellate, which was granted by Edward III in 1338, and Heron transformed the castle into a large courtyard with four corner towers. The design was possibly inspired by the newly rebuilt castle at Naworth, over the boundary in Cumberland, and is of a style that would become widely popular. Ford's principal tower was that in the north-west corner, which had five storeys.

The newly reinforced Ford Castle was included in an early example of a national defence strategy against possible Scottish invasion. The first line of defence consisted of the castles along the River Tweed, namely Berwick, Norham and Wark. Further south was the rearward chain of castles at Bamburgh, Chillingham, Etal and Ford.

Despite Ford Castle being part of this important plan, the Herons continued to be involved in a series of lawless border feuds and raids. In 1385 William Heron was thrown into prison by Henry Percy, the Earl of Northumberland, for an incursion over the border, which broke a truce. While he was detained, Ford Castle was largely destroyed by the Scots.

Scotland's King James IV stayed at Ford the night before he was killed at the Battle of Flodden in September 1513. His defeated Scots set Ford Castle alight on their retreat north and its burnt remains were left to the Herons.

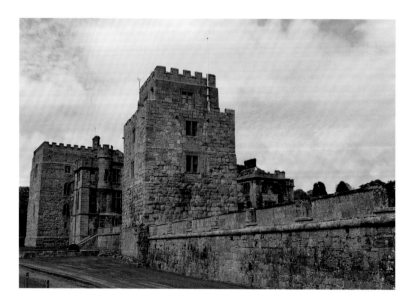

Ford Castle, looking towards the principal north-west tower.

Ford was targeted yet again in 1549, this time by a Scottish force led by a skilful French general, but despite coming under attack from four pieces of artillery, the defenders held out in one of the towers. In the same year, Ford fell into the hands of the Carrs following a marriage. This led to a skirmish with the distantly related Herons of Chipchase Castle, who took Ford by force in 1557. The Carrs were able to retake Ford, but not without bloodshed, as Thomas Carr was murdered in revenge.

Much of today's building is the result of restoration and rebuilding but the general layout remains the same.

Adjacent to the castle is the ruined Parson's Tower of 1338, a pele tower whose solid base remains, along with some higher masonry. Its upper floors were removed in the mid-nineteenth century to improve the view from Ford Castle.

Tynemouth's ancient castle was given its licence to crenellate in the thirteenth century and it continued to be of military importance until the mid-twentieth century. Pen Bal Crag, the massive rectangular headland upon which the priory was built, was fortified from the earliest recorded times. Evidence has been discovered of a large Iron Age roundhouse, but it was the burial in 651 of Saint Oswin, King of Deira, which gave the site its significance. His remains were joined in 792 by those of Saint Osred, the murdered King of Northumbria. The monastic buildings that were established in the seventh century were repeatedly attacked by the Danes, being burned in 800 and destroyed in 875.

By the time Edward the Confessor was on the throne, the priory had been temporarily abandoned and Tynemouth had become the fortress of Earl Tostig, brother of the doomed King Harold, of Hastings fame. Tostig was killed in the same year – 1066 – at Stamford Bridge, and the monastery at the mouth of the Tyne was rebuilt as a cell of St Albans by the Earl of Northumberland, Robert de Mowbray, in 1085. The castle served as a place of refuge for villagers during the years of turmoil that followed the Norman Conquest and Tynemouth's defences held for two months against the king's men after de Mowbray rebelled against William II in 1095.

The remains of the Parson's Tower at Ford Castle.

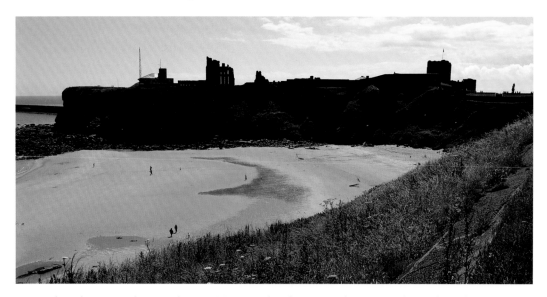

King Edward's Bay and Pen Bal Crag, Tynemouth. The ruins of Tynemouth Castle and Priory crown the headland.

With sheer cliffs on three sides, the promontory had a continuous perimeter wall by the Middle Ages – one of the longest in England at almost 1,000 yards in circumference. A defensive ditch was dug on its west side, facing the village. Looking down to King Edward's Bay from the approach road to the gatehouse, the ruin of the fourteenth-century Whitley Tower, named after Gilbert of Whitleigh, can be seen tucked into the cliffs.

The earth bank south of the gatehouse, incorporated into the sixteenth-century defences, was called the Mount, and is possibly the site of a timber tower on a Norman motte. On it is sited the East Mount Tower, which is connected to a semi-circular tower by a stretch of curtain wall called the Gallery, which incorporates sixteenth-century gunports. From the half-round tower, the wall slopes down to another tower housing a staircase, above Prior's Haven.

The square gatehouse had been built by Prior John de Whethamsted in the 1390s on the site of several earlier structures. It is similar in design to the gatehouses of Alnwick and Prudhoe, featuring a strong outer barbican with a portcullis and an inner barbican with machicolations above, allowing defenders to drop missiles on would-be attackers.

Following the Dissolution of the Monasteries in 1539, the site was leased to Sir Thomas Hilton and became a military garrison as part of Henry VIII's national defence network as he prepared for invasion after his fall-out with Rome. Advances in artillery forced the strengthening of many castles, which needed walls of greater thickness to withstand heavier bombardment. The ideas of the great German artist and innovator Albrecht Dürer, as well as Italian military engineers such as Gian Tommaso Scala and Antonio de Bergamo, were influencing English castle design. In 1545, Tynemouth castle was reinforced by military architect Richard Lee, who was assisted by the two Italians. They supplemented the fortress with substantial earth-banked bastions, which supported artillery. These were reinforced by new masonry in the eighteenth century.

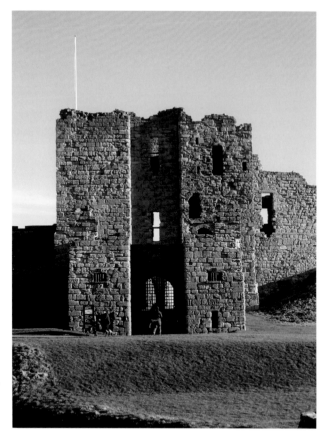

Right: Looking through the castle gatehouse to the ruins of Tynemouth Priory.

Below: The gatehouse with its projecting barbican at Tynemouth Castle. The Mount is to the right, with its sixteenth-century additions.

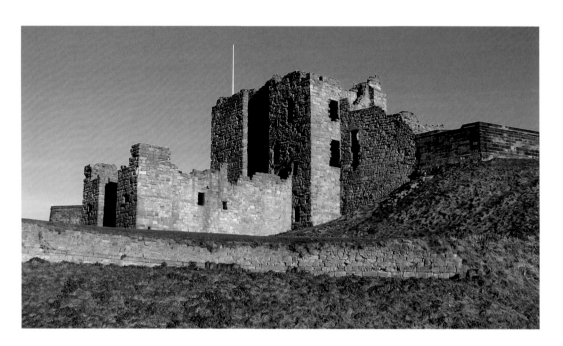

Tynemouth Castle from within. The gatehouse is seen flanked by the sixteenth-century, Italian-designed bastions.

At about the same time as Lee's improvements on Pen Bal Crag, Henry VIII fortified Tynemouth's lower headland, next to the river, which came to be known as the Spanish Battery. The Earl of Hertford used Tynemouth as his naval base for the invasion of Scotland and there were grand plans to fortify the Spanish Battery with massive bastions. In the event a ditch was dug across the headland along with a two-tier structure that was built on the battery itself. It was manned by the garrison at the castle, 600 yards away.

By 1672, even though the defence of the river mouth had effectively passed to the newly built Clifford's Fort at North Shields, Tynemouth continued to develop as a military site. The castle gatehouse was disfigured by having an eighteenth-century barracks built on top of it, and at the same time many of the monastic buildings were destroyed to make way for further military facilities. The beautiful, ornate and tiny Percy Chantry, the most intact part of the priory to survive, was in use as a powder magazine. During the Napoleonic Wars there were more than fifty large guns installed on the cliffs here. Tynemouth's defences were in use until the Second World War, and the last guns were finally removed in 1956.

Following demilitarisation, the barracks and storehouses were torn down to allow a better appreciation of the medieval buildings. A visit to the priory and castle now combines spectacular coastal views, romantic monastic ruins, medieval fortifications and twentieth-century defensive technology.

The busy market town of Morpeth was always of great importance and during the Civil War, Morpeth Castle was taken for the king, though its garrison of 500 Scots had held out there for twenty days. Only the handsome gatehouse, dating from the early fourteenth century, and some of the curtain wall remain on Castle Hill, which crowns Carlisle Park. Morpeth Castle was founded by William de Merlay and was possibly the place where Edward I stayed in 1296 when he travelled south with the confiscated Stone of Scone. The park also contains Ha' Hill, the site of an ancient motte and bailey castle which is believed to have been burned by King John in 1216.

Thirlwall Castle near Greenhead, another Northumbrian castle with a connection to Edward I, used stones taken from the adjacent Hadrian's Wall. Built by John Thirlwall

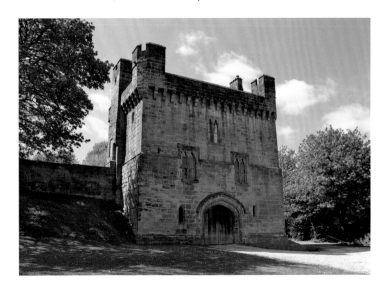

All that remains
of Morpeth Castle
is this handsome,
fourteenth-century
gatehouse and some
curtain wall.

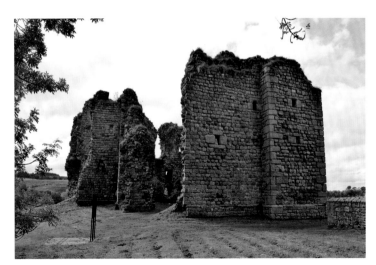

The massive stonework
of Thirlwall Castle,
which was built from
Roman stones.

on steep slopes above the Tipalt Burn in around 1300, the hall-house was a statement
of power and is supposed to have sheltered Edward I in 1306 on his last journey north.
Its 9-feet-thick walls are known to have survived many raids, and the Thirlwall family
lived here until well into the seventeenth century.

A few miles from Thirlwall is Featherstone, which like many Northumbrian castles
is a picturesque country house built around a medieval vaulted pele tower dating from
the fourteenth century. Sir Walter Scott's *Marmion* includes lines commemorating the
murder of Sir Albany Featherstonehaugh, High Sheriff of Northumberland, in 1530.
During a border feud he was killed near this family stronghold by the Ridleys.

A near-neighbour of the Featherstonehaughs, Thomas de Blenkinsopp received his
licence to crenellate from Edward III on 3 May 1340. Little survives of his original
medieval Blenkinsopp Castle, which incorporated Roman stones. It is supposed that

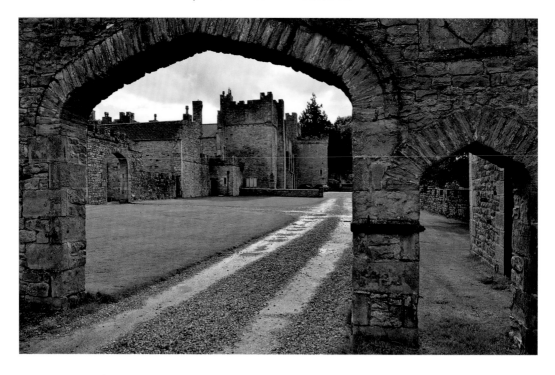

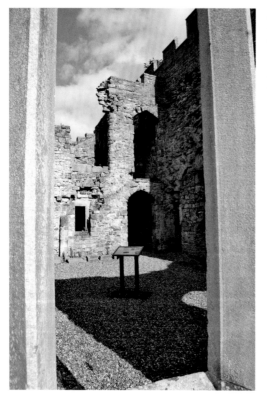

Above: The gaunt outline of Featherstone Castle, which grew from a medieval pele tower.

Left: The fire-damaged shell of Blenkinsopp Castle, which is now conserved.

the building consisted of a great hall inside a walled courtyard surrounded by a moat. By the time of a 1541 survey Blenkinsopp was already in ruins, the family having moved into Bellister Castle. In the early nineteenth century, it was recorded that a 'poor house' existed in what was left of Blenkinsopp, but by 1833 the castle was rebuilt into a grand house for the agent of the newly opened coal mine. Rebuilt again in 1880 for William Lisle Blenkinsopp Coulson, the castle suffered fire damage in 1954. Part of the building is still occupied and the ruined section is conserved.

Also dating from the early fourteenth century, the building now known as Hexham Old Gaol was effectively the town's castle keep. It was used as the prison until 1824. The nearby Moot Hall is of later construction and was built as the gatehouse of the castle, occupied by the bailiffs of the Archbishop of York. The curtain wall that once connected the two buildings is long gone. It is likely that much of the stone to build Hexham's fortifications came from *Corstopitum*, the Roman settlement at Corbridge.

The charming village street of Etal terminates at the castle built in 1341 when Edward III's licence to crenellate allowed Sir Robert de Manners to fortify his manor house there. It was described in 1355 as a *fortalice*, or lightly defended castle. His son, John, strengthened Etal with the addition of the curtain wall, a tower and the gatehouse, making it into a recognisable castle.

Another John Manners, grandson of the above-named, became involved in a feud with the Herons of neighbouring Ford Castle. This culminated in the death at Etal of William Heron, heir to Ford, in 1428.

Threatened with destruction by the huge invading Scottish army of James IV, Etal surrendered to the Scots in the campaign that would end at Flodden in 1513. After the English victory there, Etal became an arsenal of artillery weapons taken from the Scots. It was last used as a residence in 1748 and today's remains consist of the gatehouse flanked by cannons taken from the *Royal George*, the curtain wall, which is 5 feet thick, and the ruin of the tall keep.

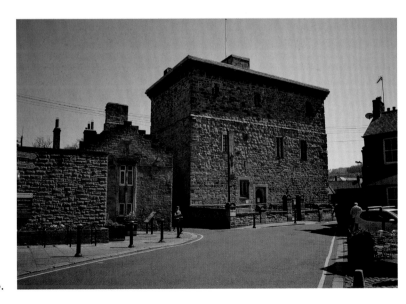

Hexham's Old Gaol was effectively the town's castle keep.

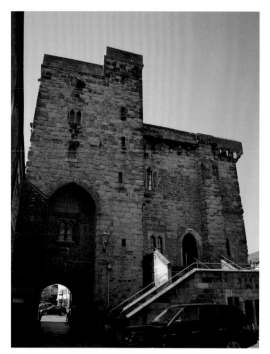

Left: The Moot Hall at Hexham was the gatehouse of the castle.

Below: The ruined keep at Etal Castle, with the gatehouse beyond.

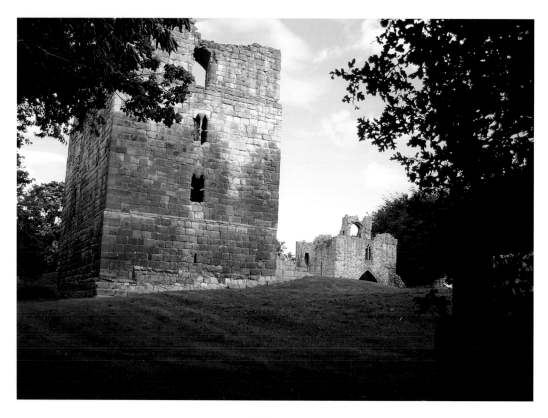

At nearby Crookham the Crookham Affray, an unimportant fight between mounted Scots and English men with loss of life to both sides, was fought in 1678. What gives it significance is that it is thought to be the last Anglo-Scottish border skirmish of all.

Dating from about 1343, when it was granted its licence to crenellate, Bothal is one of Northumberland's lesser-known castles. Its ivy-covered walls and handsome gatehouse were built by Robert Bertram, probably on the site of a Norman motte and bailey. It now forms part of a picturesque private house in a sylvan setting beside the Wansbeck and the ancient church.

Chipchase Castle's four-storey tower was built about 1348 and features a vaulted basement and turrets at each corner. It was incorporated into a seventeenth-century mansion, the building of which spelt the end of a twelfth-century tower, which is assumed to have been part of the stronghold of the de Umfraville family.

Chipchase's Sir George Heron, appointed Keeper of Tynedale, died in a border skirmish known as the 'Raid of Redesdale' in 1575.

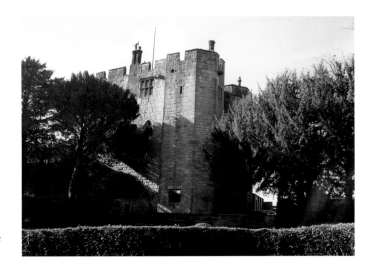

Bothal Castle's secluded gatehouse is now a private home.

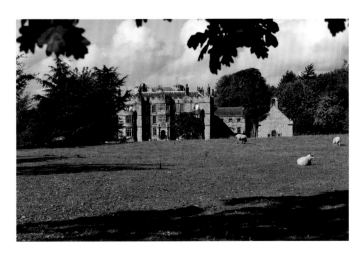

The turrets of fourteenth-century Chipchase Castle can be seen above the seventeenth-century mansion.

Well worth a visit is Edlingham castle, pronounced *'Edlinjum'*. This local idiosyncrasy applies to the pronunciation of most Northumbrian '-inghams', although Chillingham is a notable exception. During the reign of Henry II in the late twelfth century, the castle was in the hands of John, son of Earl Patrick. The most substantial surviving structure is the tall but shattered 'solar' tower house featuring rather dramatically a massive detached section, which is held by steel ties at an alarming angle. Inside is a fireplace, which is remarkable for the quality of its masonry and decoration.

Thought by many to be the finest tower house in Northumberland, the appearance of Langley Castle replicates exactly the popular image of what a castle should look like. It consists of a large battlemented square with projecting five-storey corner towers. It was built about 1350 by Sir Thomas de Lucy to protect his property from Scottish raids, but a serious fire in 1405 left the castle in ruins and by 1541 it was a roofless shell. During the seventeenth century the estate became the property of the Earl of Derwentwater, Viscount Langley. James, the third Earl, along with his brother, Charles, were executed at the Tower of London for their part in the Jacobite uprising of 1715.

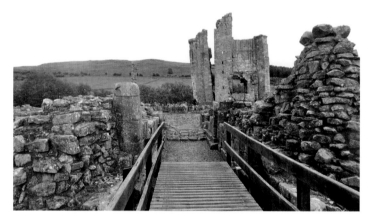

Edlingham Castle's solar tower with its spectacular vertical split.

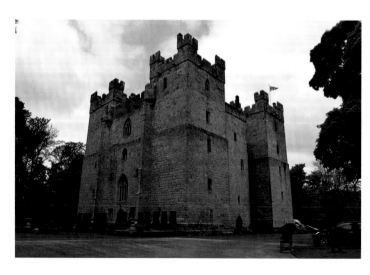

The beautifully restored Langley Castle, which is now a luxury hotel.

Langley Castle was restored in the late nineteenth century by Cadwallader Bates and it was used as a barracks during the Second World War. Having also served as a girl's school, Langley is now a hotel.

It is thought that Ranulf de Haughton built the lowest storey of Haughton Castle in the early thirteenth century. Around 1373 it was enlarged and strengthened with walls up to 11 feet thick, topped by battlements. It is a long rectangular tower house of unusual form, with four corner towers and a fifth one in the middle of the south facing wall. In 1541 a band of reivers made up of Armstrongs, Elliots and Crosiers broke through the barmkin into the enclosure and stole nine horses.

Haughton is the setting for a particularly gruesome tale, involving Archie Armstrong, chief of his clan. He had been imprisoned in the castle dungeon by Sir Thomas Swinburne of Haughton, who was then called to York to see the Chancellor, Lord Cardinal Wolsey. Days had passed since Armstrong's imprisonment when Swinburne realised to his horror that he had forgotten to make any provision for the care of his captive. Before he had

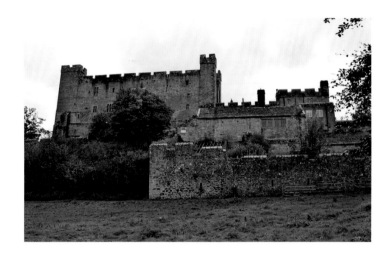

Haughton Castle's unusual, rectangular keep.

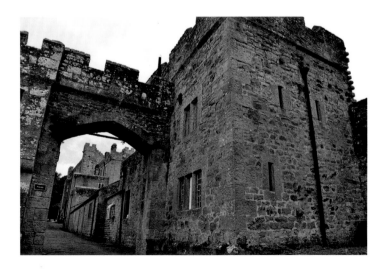

The gatehouse at Haughton Castle.

seen the Cardinal, Swinburne headed back for Haughton as fast as his horse could carry him. The poor steed collapsed and died at Durham through fatigue and when Swinburne reached Haughton his worst fears were confirmed. His prisoner had died, his facial features contorted in agony and the flesh of his forearm gnawed away.

Built about 1380 on the site of an earlier castle, Halton Tower is the survivor of four corner towers that once formed a much larger castle here, built chiefly with Roman stones taken from the fort at *Onnum* (Haltonchesters) a quarter-mile to the north. It is a massive square tower with original battlements and four round corner turrets. In peaceful times, the other three towers were replaced by a handsome, tall-chimneyed Jacobean farmhouse. Formerly the ancient seat of the Haltons, it became the property of the Carnabys, and then the Blacketts.

In 1276 the castle was occupied by Sir John Halton, Sheriff of Northumberland, who in spite of being a law enforcer was tempted into reiving. This resulted in him appearing before his own court, facing a charge of taking cattle from Thomas Fairburn of Wark.

Halton Tower displays two Roman funeral tablets as part of its masonry. Alongside is a small chapel, which was rebuilt in around 1697 but retains its original Norman arch. This whole ensemble of buildings is extremely picturesque, and enjoys panoramic views across the green Tyne valley.

Bywell Castle was built in the early fifteenth century on the north bank of the Tyne by Ralph Nevill, the second Earl of Westmorland, on the site of a much earlier fortification. It was intended to enclose a large courtyard with high walls to give protection from thieves to the villagers and their cattle. The gatehouse is crowned with extravagant battlements and corner turrets. Although work seems to have ceased after the completion of the gatehouse, Henry VI sheltered here when he escaped from the Battle of Hexham in 1464. Today's visitors will discover that, apart from the privately owned castle and two ancient and beautiful churches, there is little else to indicate that Bywell was, in the sixteenth century, a thriving village boasting fifteen shops.

As border warfare died out, the magnificent castles became romantic ruins or stately homes, while Britain's east coast needed more modern defences against new threats from beyond these shores, as we will see later.

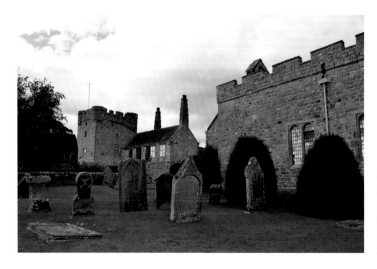

Only one tower of Halton Castle survives, which has been incorporated into a beautiful Jacobean house.

Chapter 4

The Border Reivers – Pele Towers, Bastles and Fortified Churches

There is a degree of overlap between this chapter and the previous one, for when does a large pele tower become a small castle?

Throughout the Dark Ages and into medieval times the constant threat from the raids of the border reivers, and later the so-called moss-troopers, is evidenced in the massive masonry of Northumberland's many fortified farmhouses, pele towers and bastle houses. Their sturdy stonework was often protected by an outer *barmkin* or palisade, the latter word deriving from the Latin *pilum,* which itself was the origin of the word 'pele'.

Even some Northumbrian churches had defensive capabilities, such was the uncertainty of border life.

The less wealthy, who could not afford buildings of stone, had to rely on their wits and good luck to survive, and one story relates that the poorer inhabitants of Bamburgh carried the timber frames of their houses into the castle for safety as the flame-bearing Scots approached.

There are pele towers scattered throughout England, stretching as far south as Norfolk and Cornwall. Over 200 of the 600 recognised peles are in Northumberland, compared to the total of sixty-two in Lancashire and Yorkshire. There are no two fortified dwellings alike but they typically consist of a square tower with projecting battlements, a ground floor with vaulted arches to accommodate precious livestock and living quarters for the owners above.

In addition to the peles, it is thought that over 1,000 bastle houses were built in the area in the sixteenth and seventeenth centuries, sometimes of timber. A contemporary report on the state of the borders described the houses of the *heidsmen* (the heads of families) as built of oak with turf and earth roofs. Many were later rebuilt in stone, and in later, quieter times this material would often be plundered for dry stone walling and for other farm buildings. Most bastles are therefore now in ruins, with the notable exceptions of those mentioned below.

The border hostilities that continued into the sixteenth century allowed lawlessness to flourish unhindered. The region along the frontier became known as the Debateable Land and its remoteness made it extremely difficult for either England or Scotland to govern.

Despite the Union of England and Scotland in 1603, reiving and feuding took some time to die out, and bastles and tower houses were still being built in the seventeenth century.

One of the earliest fortified buildings in Northumberland to survive intact, other than the great castles, is Edlingham Church. According to Tomlinson, the village of Edlingham, previously known as Eadulfingham, was given by King Ceolwulf of Northumbria to the monks of Lindisfarne in about AD 730. A wooden church of Saxon style was erected here. The early twelfth-century Church of St John the Baptist was built on its site adjacent to the castle and is a reminder that even places of worship had to be fortified in the border country. The thick walls and arrowslits of the church tower are testimony to this and its heavy door could be barred from the outside, which has led to the conjecture that it was used to detain prisoners.

Another example of a fortified church is at Ancroft, just south of Berwick. St Anne's Church was one of four built on the mainland by Lindisfarne's monks at the time of the Norman Conquest. The eleventh-century nave was augmented by a massive three-storey thirteenth- or fourteenth-century pele tower on its west end and a solid buttress on the south wall. The church was used as a refuge for villagers at times of cross-border trouble, the tower being accessed via a spiral staircase in the thickness of the wall.

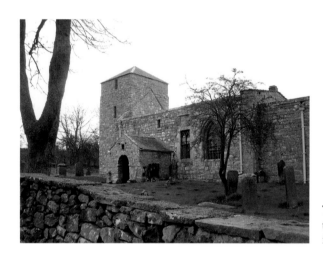

The Norman church of St John the Baptist at Edlingham, with its fortified tower.

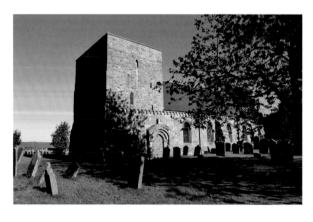

St Anne's Church at Ancroft incorporates a pele tower for defence.

The quaint-looking Blackbird Inn at Ponteland was previously the manor house of the Erringtons. It began life as a rugged pele tower, known as Ponteland Castle. A peace treaty between England and Scotland is said to have been agreed here in 1244, so it must have existed before that date. Ponteland Castle was partly destroyed along with much of the town in 1388 by James, Earl of Douglas, in a prelude to the Battle of Otterburn. The inn contains the characteristic vaulting of Northumbrian pele towers.

Aydon Castle is one of the finest fortified mansions in Northumberland, built about 1275 by Robert de Raymes, and guarded on three sides by the steep ravine of the Cor Burn. Despite its position, and the lofty outer walls containing arrowslits, it was taken by the Scots under David II, son of Robert the Bruce, in 1346, its occupants being allowed to escape with their lives.

Cartington Castle's picturesque ruin probably dates from the fourteenth century, and the building features in a list of border fortresses from 1416. It was described in 1542 as 'a good fortress of two towers and other strong houses'. Despite this description, during the Civil War this Royalist stronghold only held for a matter of hours when besieged by Cromwell's Parliamentary forces in 1648.

Corbridge, on the north bank of the Tyne, had been of strategic importance since the Romans chose it as the point at which Dere Street would cross the river. The town

The picturesque Blackbird Inn is built around the remains of Ponteland Castle, a medieval pele tower.

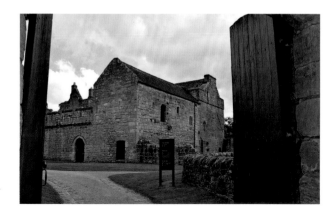

The thirteenth-century fortified mansion of Aydon Castle, as seen through the gateway.

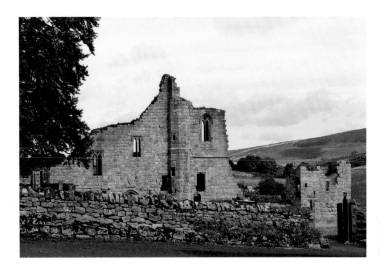

Cartington Castle's romantic ruin, with Cartington Hill beyond.

had been occupied by the Scots in 1138 and burned by Robert the Bruce in 1312, and in response to such threats the three-storey Vicar's Pele was built in the early 1300s. Situated on the edge of the churchyard, its massive construction used stone taken from the nearby *Corstopitum* Roman fort. It features a door reinforced by iron bars and the customary barrel-vaulted lower floor. It has recently been converted into an interesting micropub.

Also from the early 1300s is the 30-foot-high pele tower at Great Tosson, near Rothbury. It was a stronghold that doubled as a relatively prestigious home for the once-powerful Ogle family. The tower was roofed with sandstone roof tiles, which were pinned in the traditional manner with sheepshank bones. As well as defending the Ogles from attack, the tower was a refuge for the villagers when the border reivers paid a visit. The 'Lords' of Hepple, who were said to have been descended from Charlemagne, held court at Tosson after the Scots had finally destroyed Hepple Tower.

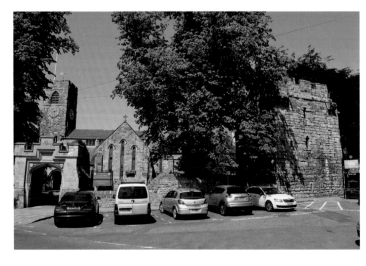

Corbridge Vicar's Pele (right), tucked inside the graveyard of the Saxon St Andrew's Church.

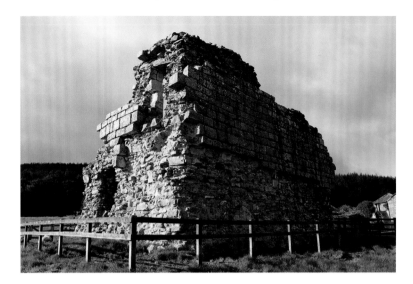

The former stronghold of the Ogle family at Great Tosson.

The importance of peles is exemplified by Hepple Tower, situated up the Coquet valley from Tosson. The Scots destroyed the chapel at Hepple, but the tower, with its great arched vault, stood firm – at least on that occasion. Later ruined by moss-troopers, its remains were found to be so strong that an attempt to plunder some of its stone for a new farmhouse were abandoned.

The shattered remnants of the early fourteenth-century Staward Pele are perched on one of the strongest natural sites in Northumberland. It is the only pele I visited that has evidence of a separate gate-tower, part of which still protects the narrow ridge which terminates at the pele itself, with its 7-foot-thick curtain walls. On three sides the ground falls steeply away, down to the River Allen and the Harsondale Burn. Stones with Roman carvings are incorporated into the masonry so the strategic importance of the site could have been recognised by much earlier occupants. The tower was given to the Friars Eremite of Hexham by Edward, Duke of York, in 1386.

Another fascinating place to visit is Belsay, a rare example of a location where three generations of houses survive, for they were all built on separate sites. The fourteenth-century castle has, like Langley, been called the finest English tower house in the North. It has a vaulted ground floor, pointed windows and corbelled battlements with corner turrets. From its rooftop visitors can look down on its Jacobean successor, built in less troubled times almost 300 years later. The original medieval tower was built by John de Middleton, whose descendant would build the magnificent neo-classical Belsay Hall of 1817. The three buildings are connected by a delightful walk through the quarry gardens.

The tiny village of Alnham still has its fourteenth-century Vicar's Pele, featuring the usual barrel-vaulted interior with 6-foot-thick walls. The fortified vicarage was later used as a youth hostel and is now a private home. The village suffered at the hands of border raiders and was burnt down in 1532. The grass-covered remains of the separate castle are on a mound near the church.

Another substantial tower house of the same era is Cocklaw Tower, near Wall. Its external austerity is in contrast to its former internal refinement, for in recent times

Hepple Tower, the remains of which are so sturdily constructed it defied attempts to plunder it for stone.

The ruin of Staward Pele, which is hidden away on its lofty perch above the River Allen.

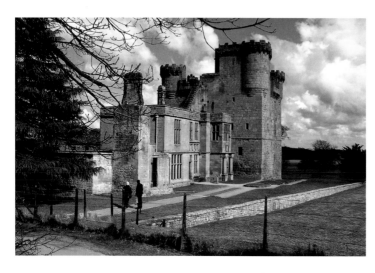

Belsay Castle, with the Jacobean house that replaced it in the foreground.

The fourteenth-century Alnham Vicar's Pele is now a private residence.

there were still traces of decorative frescoes on its walls. It was the residence of the Errington family from 1372 to 1567.

Dating from about 1380, Hepburn Bastle is a bit of a curiosity in terms of its name. Probably built in the late fourteenth century, it is quite unlike any other Northumbrian bastle and is more like a fortified tower house. It is first recorded as a 'hold' in 1509 but by 1542 it is described as a tower, and by 1564 it had been promoted to a mansion house! It is the only surviving building of what was once a large village. Despite being in ruins

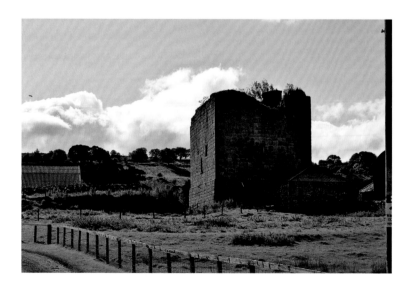

Cocklaw Tower, whose austere appearance belies its once opulent interior.

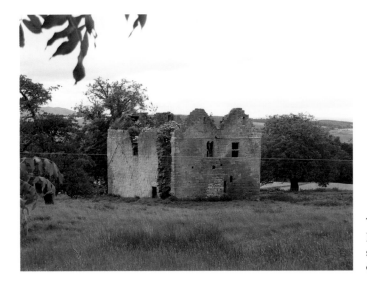

The misnamed Hepburn Bastle, the only surviving building of this once-thriving village.

for hundreds of years, Hepburn Bastle still stands three storeys high. The ground floor is barrel-vaulted like conventional bastles, as if it was originally used to protect livestock from raiders. The windows in the upper floors were added in later, quieter years.

The tiny village of Ninebanks is on the edge of the remote Northumberland and Durham lead-mining district, close to the border with Cumberland. Still standing is Ninebanks Tower, said to have belonged to Sir John Eden and possibly dating from the fourteenth century. It may have been built as a lookout, although it features projecting spouts that could have been intended for pouring locally mined molten lead on enemies.

Also dating from the fifteenth century, Bellister Castle was originally a small but strong pele tower that was surrounded by a moat. It was occupied by the Blenkinsopp family, who had relocated from the castle of the same name. The remains of the medieval tower are incorporated into a later, castellated house.

The pele tower at Cresswell, formerly home to the family of the same name, is unusual as it is so close to the coast. Tomlinson said it was one of the finest specimens of a fortified mansion house in the county. There was one way into the living quarters on the upper floors, via a narrow and easily defended staircase.

Up the first flight of steps there was a kitchen, living area and, unusually for a Northumbrian pele, a garderobe (privy) built into the thickness of the wall. The second floor was unheated and was used for sleeping. Further stairs led from here to the rooftop parapet.

Contemporary with Cresswell Tower, the Vicar's Pele at Elsdon is said to have walls measuring 10 feet in thickness. Visible across Elsdon Burn from the motte and bailey, it stands in an equally commanding position over the village. It was built for the protection of the Rector of Elsdon and remained a vicarage until recent times. In the sixteenth century, the top three of its four storeys were rebuilt into two. The original barrel-vaulted basement survives, as do the machicolations on the north side. The tower's parapets feature the carved arms of the Umfraville family, the Percys, the Howards and the Lucys. Elsdon's is one of the largest and most imposing Northumbrian pele towers.

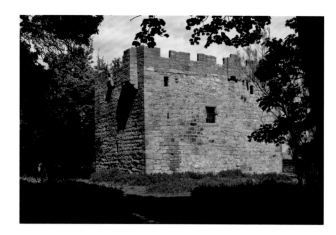

Cresswell's coastal pele, with the North Sea glimpsed to the right.

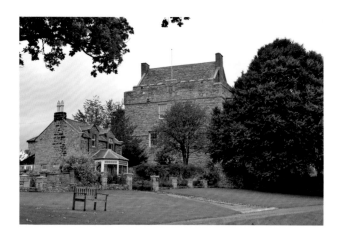

Elsdon's Vicar's Pele dominates the village skyline almost as much as the motte and bailey.

The gaunt remains of another fortified vicarage stand beside the main road in Ponteland. This Vicar's Pele, dating from the beginning of the fifteenth century, was built as protection from the moss-troopers.

Whittingham Tower is a well-preserved fifteenth-century pele with 8-foot-thick walls, which Tomlinson said had 'doubtlessly witnessed many a scene of violence and bloodshed'. It was once the property of William Heron and was later used as an alms-house for poor women. At nearby Thrunton Farm some bronze swords and spearheads were found in a bog. They were taken to Newcastle and are known to be at least 2,500 years old.

Just north of Alnwick, on the old Great North Road is the wooded eminence of Heiferlaw. In the fifteenth century the area surrounding Alnwick suffered greatly during a prolonged series of raids from north of the border. The monks of Alnwick Abbey built Heiferlaw Tower in about 1470 as a lookout post, and a very effective one it would have been before the plantation, with panoramic views down to the coast. Interestingly, about 200 yards to the west lie the remains of an Iron Age defended settlement, which itself contains a subterranean Second World War control station, so this location neatly encompasses the entire time period of this volume.

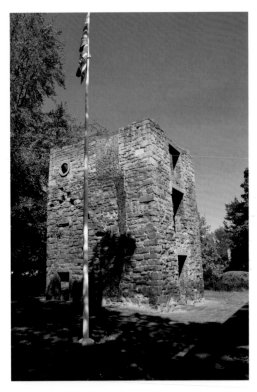

Left: Ponteland's ruined Vicar's Pele stands proud beside the main road.

Below: Whittingham's pele tower witnessed 'many a scene of violence and bloodshed'.

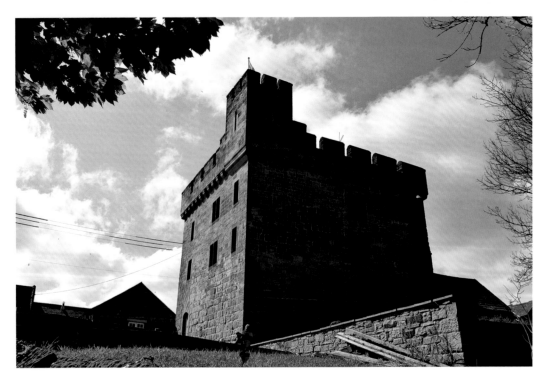

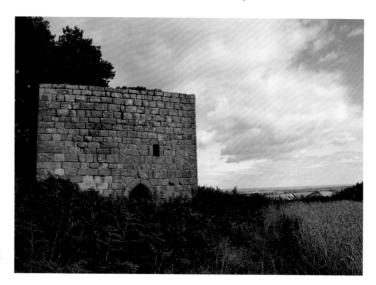

Heiferlaw Tower, which was built as a lookout by the monks of Alnwick Abbey.

Corbridge Low Hall was built by the Baxter family, and like the earlier Vicar's Pele it reflects the unsettled nature of life in medieval Tynedale. It was originally an early fourteenth-century hall-house, with a 'solar' tower. In about 1480, it was converted to a rectangular pele tower house and was named Baxter's Tower. Low Hall was large for its time, with three floors and featuring a pitched roof with defensible parapets. The building was rebuilt in the sixteenth, seventeenth and nineteenth centuries, but the tower has kept many of its medieval features, including the ground floor vaulting and the original staircase contained within the thickness of a wall.

Hulne Priory, near Alnwick, had a defensive curtain wall like most monastic sites in the region, much of which survives. In case this was breached in an attack, the Lord's Tower was built by Henry, 4th Earl of Northumberland, in 1480. It is a rare example of a pele tower within a monastery, and was a place of refuge for the Carmelite monks.

Corbridge Low Hall, which incorporates a medieval pele tower at its east end.

Another fine late example of a pele tower is the Horsley Tower at Longhorsley. The early sixteenth-century structure, built for the wealthy Horsley family, has the characteristic vaulted basement and features a spiral staircase up to the battlements.

In about 1685 the building was handed to the Widdrington family and by 1763 to the Riddells. They made the top floor into a Roman Catholic chapel, which was in use until replaced by the new church in 1841.

Even on the Farne Islands it was deemed necessary to build a pele tower for protection and as a deterrent. Prior Castell's Tower was named after the Prior of Durham Cathedral, who had it built around 1500 on the Inner Farne, which lies 2 miles off the coast just south of Bamburgh.

It was first used by monks who sought solitude on the island. After Henry VIII dissolved the monasteries, the strategic importance of the islands led to Prior Castell's Tower housing a garrison of four men.

In the early seventeenth century, the pele was in ruins, being redundant to the military, but by the 1670s permission was granted for a beacon to be lit on the tower. In 1809 this was replaced by a purpose-built lighthouse. Today, Prior Castell's Tower is used as accommodation for National Trust rangers on the islands.

Even in the sixteenth century the border region was a lawless one. Marauding bands of reivers from both sides of the border were a constant threat. The bastle was a defensive structure of utilitarian form and several were built in the valley of the North Tyne and its tributaries. Black Middens was one of these and like many of its neighbours it was repeatedly attacked, despite its walls of 5 feet in thickness. In 1583 it was reported by the Warden of the English Middle March that Kinmont Willie and 300 Armstrong kinsmen had burned eight farmsteads in the valley, including Black Middens, killing six people and taking thirty prisoners, along with hundreds of sheep, goats and horses.

On a rocky eminence in the hamlet of Duddo stand the late sixteenth-century remains of Duddo Tower, which was once the stronghold of the Lords of Tillmouth. Its predecessor was destroyed by James IV of Scotland in 1496. Its location would have provided a sweeping vantage point across the Plain of Milfield to the hills of southern Scotland.

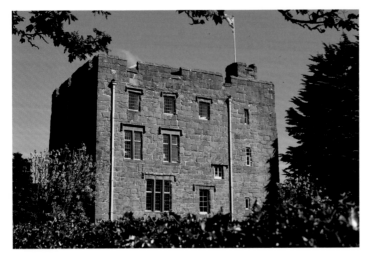

Horsley Tower – one of the last, and one of the finest, peles.

Inner Farne from Bamburgh, with Prior Castell's Tower at the north end.

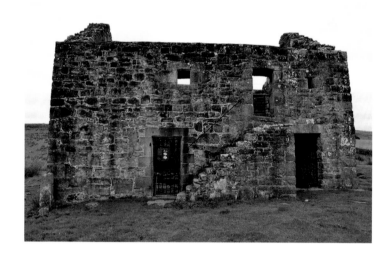

Black Middens Bastle survived burning and bloodshed.

Duddo Tower is all that remains of the stronghold of the Lords of Tillmouth.

Dating from 1584, Doddington Bastle is, despite its name, more like a pele tower, and is unusually of four storeys, reaching a height of well over 30 feet. It was built by Sir Thomas Grey of Chillingham to guard against Scottish raids. Doddington was the last of its kind to be constructed before the historic Union with Scotland. Its lofty ruins are surprisingly well hidden and look somewhat precarious.

Woodhouses Bastle, near Hepple, was built as protection from border reivers, and is one of the best preserved examples of these distinctive Northumbrian structures. Most of its counterparts are in ruins now but Woodhouses was occupied until the early twentieth century, hence its intact state. Its thatched roof was replaced by one of slates in 1904. It has a date stone from 1602, which is possibly carved with the names of William and Bartholomew Potts.

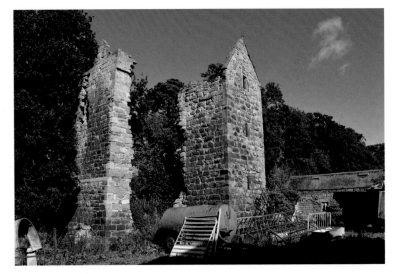

Doddington Bastle's precarious and lofty ruin.

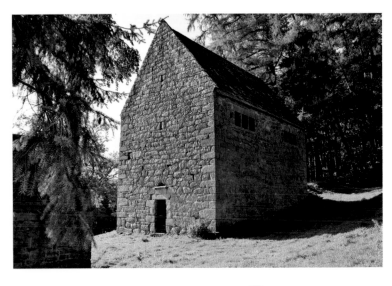

Woodhouses Bastle survives intact.

The interior of Woodhouses Bastle was still inhabited as late as the twentieth century.

Chapter 5

Fortified Towns

Newcastle-upon-Tyne's defensive town wall dates from the thirteenth and fourteenth centuries and was commissioned because of the constant threat of invasion from Scotland. The circumference of the wall was over 2 miles and it was protected by an outer ditch. There were six main gates, such as the West Gate and New Gate – some of which were also used as prisons. Newcastle successfully defended herself from attacks by the Scots more than once but in the Siege of 1644, during the Civil War, the Scots finally managed to breach the walls after ten long weeks. In 1715, however, they stood firm against a Jacobite attack.

Much of the wall fell into disrepair as hostilities with Scotland ceased. As the medieval town expanded into today's city and spread beyond the wall, much of it was demolished, and its masonry was used in new buildings. Despite this, a surprising amount of the medieval town wall survives in modern Newcastle, especially on the west side.

From the Close on the Quayside to the west of Stephenson's High Level Bridge, the 'Breakyneck Stairs' accompany the town wall as it climbs steeply from the Tyne. At the top there is an impressively tall stretch complete with full-height parapet near Hanover Square, south of the Central station. The base of the Gunner Tower can be seen on Pink Lane and the wall reappears north of Westgate Road with a long section alongside Bath Lane, past Durham Tower and up to Heber Tower.

At this point the wall makes a sharp turn north-eastwards behind Stowell Street, where another tall length of wall can be seen, crowned by the Morden Tower and terminating at the Ever Tower. A stretch of ditch has been re-excavated here, which for many years was hidden beneath the coach station. Across Darn Crook it continues through St Andrews Churchyard, where a long section of it supports the backs of modern buildings on Gallowgate. The church bears the marks of conflict, for there is visible cannonball damage from Scottish guns. In that same Civil War, the church tower had been used for the firing of a gun, which contributed to its structural weakness.

East of St Andrews, only a few fragments of the wall remain: Plummer Tower near Croft Street with its seventeenth-century additions; and the Corner Tower and Sallyport, or Wall Knoll Tower, near City Road. The latter is the only surviving gate. During the reign of Henry VIII, the opinion of the antiquary John Leland was that Newcastle's walls in 'strength and magnificence far passeth all the walls of the cities of England'.

Berwick's medieval town walls, which had been under construction for many years, were finally completed by Robert the Bruce in about 1318, after he had exploited their incomplete state when taking the town by force. The walls once reached up to 30 feet in height and were defended by nineteen towers and seven gateways. Typically, the towers

Right: Morden Tower on Newcastle-upon-Tyne's medieval town wall.

Below: The Sallyport, or Wall Knoll Tower, at Newcastle-upon-Tyne.

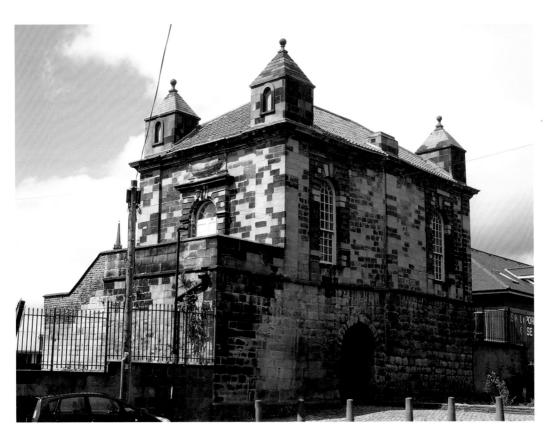

were semi-circular, projecting outwards from the curtain wall with walls that were 4 to 6 feet in thickness. The masonry was later reinforced by the addition of the 'countermure' or earth embankment behind the wall, to make the defences more resistant to artillery, and as a precursor of the later bastions. The countermure can be seen with fragments of the medieval wall beside the distinctive Bell Tower, which was designed to provide a vantage point for defenders to warn of approaching enemies. This octagonal structure was built in 1577 to replace an earlier one, which had stood on the site of Lord's Mount. The bell was last sounded in 1683. In Tudor and Elizabethan times, Berwick's walls were largely replaced by an ambitious new set of defences, which is covered in Chapter 7.

The fifteenth-century town wall at Alnwick once had four gates but only one, Hotspur Tower, survives intact. It was built by the second Earl of Northumberland, the son of Henry Hotspur, who was killed at Shrewsbury. Through the Hotspur Tower's narrow passage runs Bondgate, with modern traffic having to squeeze through in turn. The tower was once used as a prison and the narrow window slits in its semi-octagonal towers are a reminder of this. Another tower at the top of Pottergate was completely rebuilt into a much more decorative form in the late eighteenth century and still stands.

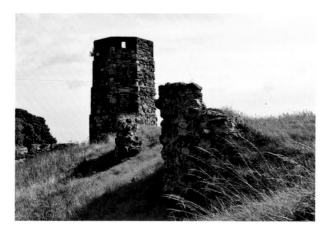

Part of Berwick's medieval town wall, with the later Bell Tower.

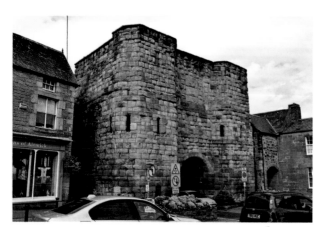

Alnwick's Hotspur Tower, separating Bondgate Within from Bondgate Without.

Chapter 6

Some Famous Northumberland Battles

The Battle of Carham, or Wark-on-Tweed

Some confusion exists over not only the date of this pre-Conquest border battle, but also over its exact location. It was fought in either 1016 or 1018 at either Wark-on-Tweed or Carham. What is known is that King Malcolm of Scotland and Owain 'the Bald' of Strathclyde defeated Uchtred, the Earl of Northumberland. Uchtred's army was decimated despite having supposedly recruited every eligible fighting man between the Rivers Tyne and Tweed. One outcome of this battle was the establishment of the border along the latter river.

The First Battle of Alnwick

With the Norman King William II of England busy fighting for control in Normandy, Malcolm III of Scotland tried to claim northern England, but when he invaded in 1093 he died in an ambush at Alnwick at the hands of the men of Robert de Mowbray, the Earl of Northumbria. King Malcolm's body was buried at Tynemouth Priory.

There is a monument that marks the site of the Battle of Alnwick, just off the B6341, to the north of the town.

The Second Battle of Alnwick

Just over eighty years after Malcolm's ill-fated foray into Northumberland, William 'the Lion' attempted to succeed where his predecessor had failed. William had already tried and failed to invade Northumberland, attacking the castles of Newcastle, Alnwick, Prudhoe and Warkworth, but all attempts were repulsed. In punishment for these attacks, Berwick-upon-Tweed was raided by the Chief Justiciar of England, Ranulf de Glanville. This was followed by a short-lived truce, but the irrepressible William ended this when he launched another unsuccessful assault against Prudhoe Castle.

William then commanded his Scottish army to divide, with the main force aiming for Alnwick while Duncan, the Earl of Fife, was sent to attack Warkworth. William's men laid siege to Alnwick Castle but were challenged by de Glanville and his men, who had been dispatched from Newcastle.

Although it is claimed that the Scottish force totalled 80,000 men, this is highly unlikely, and in any case they were thinly spread around the long perimeter of Alnwick Castle. On 14 July 1174, the camp of the Scottish king came under surprise attack, and he was taken prisoner.

The Battle of Halidon Hill

In the aftermath of Bannockburn (1314), Northumberland was plunged into a state of continual border warfare. Following the death of Robert the Bruce in 1329, Edward III of England decided to make Scotland a subordinate kingdom.

Edward's men besieged Berwick in 1333 while the Scots under Sir Archibald Douglas had amassed a large army. Douglas made for Bamburgh Castle where King Edward's consort, Queen Philippa, was staying. Edward must have felt satisfied with security at Bamburgh and continued to hold Berwick. The English king began hanging two Scottish hostages daily, which forced Douglas to engage in battle at Halidon Hill, to the north of the town, on the modern border. On 19 July 1333, the Scots occupied the hill named Witches' Knowe, which was an advantageous position. Edward's men, meanwhile, were on the neighbouring Halidon Hill, between the Scottish army and Berwick.

The Scots descended into the boggy ground that separated the two hills, slowing their advance and allowing Edward's archers to slaughter the first waves of the attack. Successive Scottish advances were also met with hailstorms of English arrows. King Edward, meanwhile, turned his attention to campaigns in France rather than 'finishing the job' north of the border. Halidon Hill conclusively demonstrated to the king the devastating effect of the English bowmen, a strategy that Edward employed in France at Crécy and Henry V later used at Agincourt.

The Battle of Otterburn

Also known as Chevy Chase, the Battle of Otterburn was a glorified border skirmish that took place in August 1388. James, the 2nd Earl of Douglas, had ravaged Northumberland and Durham and challenged Sir Henry 'Hotspur' Percy at the gates of Newcastle. Returning to Scotland after destroying the tower at Ponteland, Douglas waited at Otterburn for Hotspur. The English, weary from their march from Newcastle, attacked under moonlight. Hotspur was captured, but not before he had killed Douglas. Casualties on both sides were heavy but the English suffered the worst.

The Battle of Humbleton (also known as Homilden) Hill

News of this 1402 battle forms the beginning of Shakespeare's *Henry IV*. An army of 10,000 Scots led by Archibald, the Earl of Douglas and great-nephew of Douglas of Halidon Hill infamy, invaded Northumberland. This was to avenge the death of Sir Patrick Hepburn, who had been killed in a skirmish some months previously. They ravaged the county as far as Newcastle and on returning north they were met by the Earl of Northumberland and Harry Hotspur. The English archers decimated the Scotsmen on the lower slopes of the hill, with 800 being killed here and another 500 said to have drowned trying to ford the Tweed. Douglas himself was badly wounded and captured.

The Battle of Hedgeley Moor

The battle took place in April 1464 during the Wars of the Roses, when the Yorkists under John Neville, Lord Montagu, defeated the Lancastrian troops of Sir Ralph Percy and the Duke of Somerset. A month later the resistance of the men of the Red Rose in the North was finally crushed at the battle of Hexham.

The Battle of Flodden

This most famous and bloody of Northumberland's battles took place in September 1513. James IV of Scotland and Henry VIII of England were brothers-in-law but when Henry crossed the English Channel in June 1513, James tried to aid his French allies by invading England.

Backed by up to 60,000 men, he stormed Norham Castle before taking up an impregnable position on the top of Flodden Hill. The redoubtable septuagenarian the Earl of Surrey had advanced from Alnwick with 26,000 troops, the vanguard of whom had used the newly built Twizel Bridge to cross the River Till. James descended from his position with his men to give battle, losing his advantage in doing so. It was said that every notable Scottish family had contributed a father, son or brother to James' army; and among the 10,000 Scots to die were the king himself, three bishops and thirteen earls.

The graceful Twizel Bridge, which played an important part in the build up to the Battle of Flodden in 1513.

Chapter 7

Later Defences and the Threat from Abroad

Berwick's defences were greatly strengthened in the sixteenth century, beginning with the construction of an impressive gun emplacement named Lord's Mount. Henry VIII embraced new technology and is supposed to have had a hand in its design. It was a two-storey circular structure with positions for six radiating guns, and was placed strategically, facing open country to the north. South of here, the headland on which the town is sited was protected by the most impressive defences in Britain, and the best surviving example of their kind in Europe. These are the ramparts designed by Sir Richard Lee and commissioned by Queen Mary I. Their building came about because the French had taken Calais and were now urging the Scots to invade Berwick.

The defences were based on a state-of-the-art Italian design, with angular bastions shaped like arrowheads in plan view. With their thick masonry and massive embankments they were designed to withstand artillery fire. They were never tested in battle, although in the Second World War British soldiers practised Bren gun fire against them. In Elizabethan times, cannon were ranged along the top, with flanking guns hidden behind each arrowhead bastion to fire across any would-be attackers.

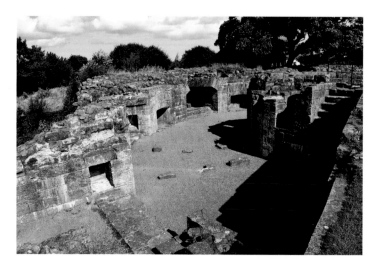

Lord's Mount,
Berwick-upon-Tweed,
a gun emplacement
attributed to Henry VIII.

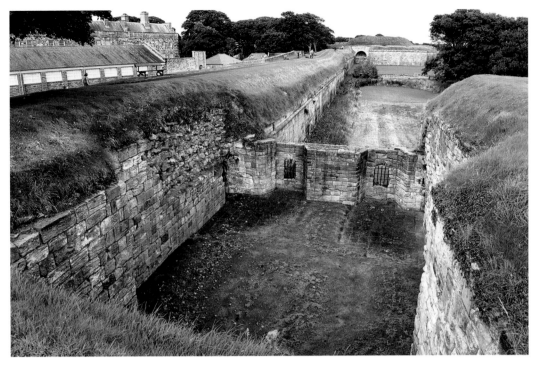

Berwick ramparts, looking down into one of the positions for cross-firing artillery.

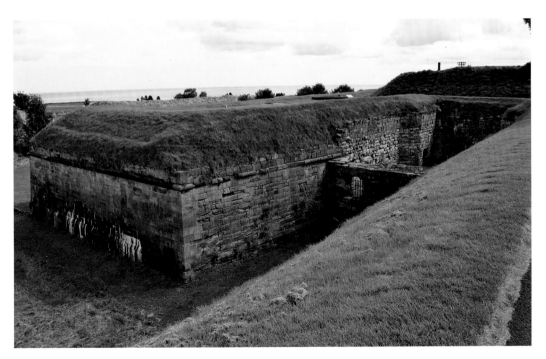

One side of an 'arrowhead' at Windmill Bastion, Berwick ramparts.

There were heavily defended gates let into the structure, such as the Cowport with its portcullis. Any approaching traffic had to cross a wooden drawbridge, across a broad ditch that was originally flooded, to reach the gate. The sheer scale of these fortifications can be appreciated by looking at aerial photographs of Berwick, and they are no less impressive at ground level, or indeed when walking on top of them.

Berwick remained an important frontier town for many centuries, and when the religious policies of Charles I threatened to provoke a Scottish rebellion in 1638 its defences were strengthened again. During the Civil War the town had a Scottish garrison, and later Oliver Cromwell with his English troops enlarged and armed the town's ramparts.

Lindisfarne Castle is perched proudly on top of a 100-foot-high rock. The little fortress was built in 1550 to the orders of Henry VIII, using material taken from the recently dissolved Priory. During the Civil War, Lindisfarne was held first for the king and then later for Parliament. In 1715 it was taken by Jacobite rebels led by Lancelot Errington through the simple means of inviting its garrison on-board a rebel ship and getting them drunk. The insurgents abandoned the castle when no reinforcements arrived and were later captured. By the early twentieth century the castle had been converted into a private home by Sir Edwin Lutyens and is now a National Trust property.

In 1672, on the outbreak of the third Dutch war, a new fort named after Lord Clifford, of Cabal fame, was built at North Shields, where the Tyne widens from river to estuary. Clifford's Fort included the existing Low Light in its perimeter. This was one of a pair of lighthouses – one at quay level and the other on the cliff above – which, when aligned with one above the other, indicated to sailors a safe course into the treacherous river mouth.

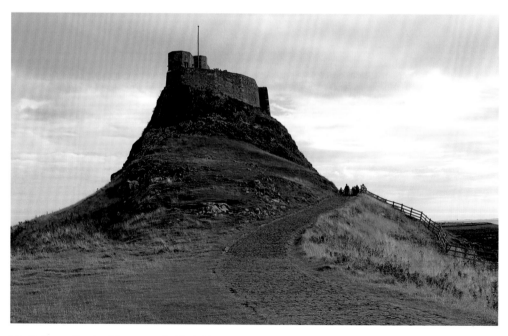

Lindisfarne Castle. (Photograph Chris Heaton)

The land upon which Clifford's Fort was built belonged to Ralph Milburne of East Chirton, and it is said that King Charles II never paid him for it. It was left to Milburne's widow to put in a claim for £150 to the Treasury in 1708.

The fort featured a three-storey keep with a central turret, and was commanded by the governor of Tynemouth Castle. Like many later Northumbrian military installations, the history of Clifford's Fort is not an action-packed one. Perhaps its most interesting episode was the celebrated 'siege' of 1804, with an unexpected 'enemy'. The fort, along with Tynemouth Castle and the Spanish Battery, had recently been entrusted to the North Shields & Tynemouth Volunteers. The company had not long been in position when Major Doyle of the Light Brigade from Sunderland, along with one company each from the 61st Regiment, the Northumberland Militia and the Lanark Militia, crossed the Tyne from their camp at South Shields, which was of course then in County Durham.

The major had boasted that he could easily surprise any of the Northumbrian forts garrisoned by the volunteers and his officers, under the influence of alcohol, 'dared' him to make the attempt.

Their flat-bottomed boat, the 'Buonapart', landed on the Low Light Sands in the early morning. With Doyle himself leading on his charger, the 'invaders' proceeded as noiselessly as possible and made their way up the narrow passage close to the fort. Their landing had been observed, however, and word had been sent up the bank to Dockwray Square, where many of the volunteers were on parade.

A scuffle ensued, after which the invaders from Durham attempted to take the fort by storm. Captain Robert Shields of the Volunteers, who had been captured by the Northumberland Militia, had to be rescued, and eventually the assailants were repulsed. By the time they had retreated over the Tyne they found that Captain Shields and his men had slipped across the river ahead of them, demolished their camp and carried off their colours!

In later years, Clifford's Fort was the home of the Tyne Division Royal Engineers (Volunteers) Submarine Miners, and it was provided with its own mine-laying vessels.

During the First World War, the engineers of Clifford's Fort were responsible for searchlights, signalling and other communications, and the garrison was strengthened by the arrival of HMS *Illustrious* along with a detachment of Royal Marines and a battery of three guns. The Great War brought two new threats to our defences, with much of the work at Clifford's Fort focusing on detecting and combating U-boats, and in January 1915 came the first air raid on Britain, when a Zeppelin airship flew a sortie over Norfolk.

A second raid occurred on 14 April 1915 under the command of Kapitän-Leutnant Mathy. This was ostensibly a reconnaissance flight over the Yorkshire coast but, with bombs on board, Mathy wirelessed his commander for permission to divert to the Tyne. Zeppelin L9 appeared off Tynemouth at 7 p.m., and at Blyth she was met with rifle fire from the 1st Battalion Northern Cyclists at Cambois. The first German bomb fell at nearby West Sleekburn. Twenty-two others followed before she swung south over the Tyne at about 8.40 p.m. The only casualties were a woman and child who were injured in Wallsend. The engineers of Clifford's Fort were soon called upon to install anti-aircraft searchlights.

Such a searchlight, along with a 3-inch anti-aircraft gun, was in place at Carville, Wallsend, by 15 June 1915 – the date of the next Zeppelin raid on the Tyne. Zeppelin L10,

in the charge of Kapitän-Leutnant Hirsch, reached the coast at Blyth, avoiding Tynemouth's defences. Having received no warning, Tyneside's nocturnal industries were illuminated at full blaze. The North Eastern Marine Engine works, where my grandfather worked, along with the collieries at Wallsend and Hebburn were bombed. Palmer's shipyard at Jarrow was the next target, where seventeen men were killed and many more injured.

On her way out to sea, L10 dropped further bombs on Willington Quay, East Howdon, Cookson's Antimony works and Pochine Chemical works. Altogether, more than 2 tons of explosives had been used, and although two naval aircraft were dispatched from Whitley Bay, they saw nothing of Hirsch and his Zeppelin. The airship, a mile above Wallsend, had been visible from the ground, and should have been an easy target, but the defences were poorly organised and the guns came into action too late. Hirsch claimed to have bombed the coastal battery, which fired on him on his way out to sea.

Following complaints from many Tyneside industries about the lack of warning, a system was set up whereby multiple firms and locations would receive a simultaneous alarm. It was the first of its kind in Britain.

By April 1916 there were several searchlight and anti-aircraft gun stations cooperating with aerodromes at Cramlington and Whitley Bay. On 8 August 1916 a German raid took place involving four Zeppelins. Hampered by fog, one of the airships was believed to have been hit by a Whitley Bay gun, and the Germans caused very little damage this time.

After the Armistice, Clifford's Fort was used by the Territorial Army, and when their new base was built next to Tynemouth station, most of the fort was cleared away to allow for the expansion of North Shields Fish Quay in 1928.

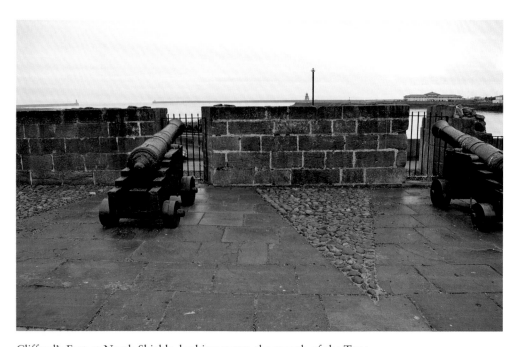

Clifford's Fort at North Shields, looking out to the mouth of the Tyne.

Berwick's impressive barracks were built in 1717 and are said to be the oldest in the country. Their design is attributed to Nicholas Hawksmoor, better known for London churches and Oxford colleges. The Barracks now house Berwick's museum, as well as one dedicated to the local regiment, the King's Own Scottish Borderers. In 1749 a purpose-built powder magazine was constructed at a suitable distance from the Barracks.

Also in Berwick is the guardhouse known as the Main Guard; a handsome Georgian building, it used to stand in Marygate and moved to its present site in 1815.

Pen Bal Crag at Tynemouth, with its ancient monastic ruins, saw its gun batteries modernised with breech-loading guns in 1893 and again in 1904. The Admiralty established a signalling station here during the First World War, by which time a 9.2-inch Mk X gun with a range of 7 miles was in operation, as well as two 6-inch Mk VII guns.

Visitors to the castle and priory can view the concrete gun emplacements and the underground magazines below, where displays explain the precautions taken to prevent accidental explosions.

Berwick Barracks, which now contains two fascinating museums.

The Powder Magazine, which was built a safe distance from Berwick Barracks.

The Main Guard is Berwick's guardhouse. The building was physically moved 200 years ago.

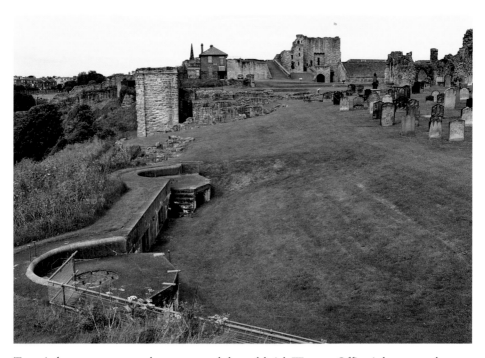

Twentieth-century gun emplacements and the red-brick Warrant Officer's house can be seen among the medieval ruins at Tynemouth.

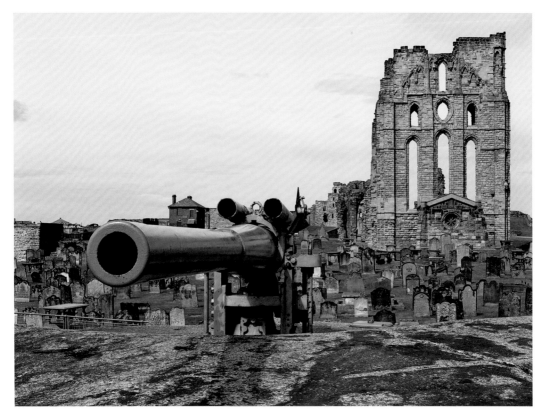

Tynemouth Priory forms the background to a twentieth-century gun pointing out to sea.

In response to the Zeppelin attacks mentioned earlier, a watchtower was built in 1916 behind a house belonging to the War Office in Percy Gardens, Tynemouth, 1 mile from Clifford's Fort.

47A Percy Gardens was a command centre providing a lookout for the crews of gun turrets at Marsden in South Shields and Seaton Sluice to the north. In order to permit a clear view out to sea over the rooftops of the grand Victorian terrace, it was built to be six storeys high, making it one of the tallest of its kind anywhere.

As it happened, the tower and associated gun turrets were not completed until after the war, but the guns were tested before being closed down. The tower is now a listed building, having been used again during the Second World War. Since then, it has been converted into a private residence.

Another unusual survivor of Northumberland's First World War coastal defences is the disused railway embankment and bridge abutments to the south of Seaton Sluice. Originally planned as a passenger line, construction of the North Eastern Railway's branch to Collywell Bay (Seaton Sluice was not deemed to be an attractive enough name!) was halted when war was declared in 1914. By 1916 the Ministry of Munitions & Railway Executive Committee, faced with a shortage of materials, removed the unused rails. A 2-mile stretch was then re-laid with second-hand track to carry a naval coastal defence gun on a specially built wagon.

Left: Tynemouth's First World War watch tower.

Below: The only train ever carried on the Collywell Bay branch was a rail-mounted gun.

Incidentally, on the flat expanse called Ross Links, just south of Lindisfarne, was a 'target railway', which was constructed so that warships moored off the coast could practise hitting moving targets.

A few miles north of Tynemouth and contemporary with the watchtower is Blyth Battery, a coastal defence artillery installation to protect the Port of Blyth, which was at one time Europe's largest exporter of coal. The busy harbour here also held a First World War submarine base, which was re-equipped for the Second World War.

Blyth's 1916 twin gun emplacements housed 6-inch guns during both world wars. The concrete canopies and brick rear walls were added during the Second World War to protect their crews from the Luftwaffe. The battery observation post also survives from the First World War. This building housed the battery commander, as well as signallers who would pass on his orders to the whole battery. The revolving armoured turret on top contained the rangefinder for aiming the guns. A new observation post was built in 1940 with more advanced technology, meaning that orders could be issued to other Northumbrian coastal batteries at Amble, Berwick and Druridge Bay.

Behind the observation posts is the 1916 blockhouse (or pillbox), which had nine loopholes for the firing of rifles. This was part of the defensive system to protect the battery from attack on the landward side. There would have been an encircling ring of barbed wire and corrugated steel fencing. The two First World War electric searchlight emplacements can be seen a short distance from the main battery buildings. The buildings contained quarters for their crews and gun loopholes for protection. Steel shutters covered the lights when not in use.

Observation posts from both world wars can be seen at Blyth Battery.

One of the searchlight emplacements at Blyth Battery.

Blyth Battery is open to the public, being the most intact and accessible coastal defence installation on the North East coast.

As well as the World War Two defences at Tynemouth and Blyth, Northumberland played her part in the defence of Britain's skies, being home to several RAF bases during the Second World War. These include Milfield – from which I took off for my aerial hillfort photography – along with Eshott, Acklington, Morpeth and Woolsington, the latter of which is now Newcastle International Airport.

Close to Newcastle Airport is Kenton Bar, where one of Britain's four RAF Fighter Command Headquarters was hidden in a secret bunker. It was part of a larger RAF complex and served as part of the national air-defence system during the Second World War. Its role was to coordinate the air defence of northern Britain, and as such it played a key part during the Battle of Britain. As part of the modernisation of the national air defence system by Air Chief Marshal Dowding, the system integrated new radar technology with human observation, air raid plotting and the radio control of aircraft. Kenton Bar was responsible for Northern England, Scotland and Northern Ireland. It became fully operational in August 1939, with the Royal Observer Corps Units and radar stations under the command of the Air Vice-Marshal R. E. Saul DFC.

With most of the early action in the Battle of Britain taking place over the South and East of England, the area controlled by No. 13 Group was relatively calm. However, on 15 August 1940, a major attempt was made by the Luftwaffe from Nazi-occupied Norway to break through Britain's northern defences. Their strategy involved the use of a decoy squadron of seaplanes bound for Scotland, while bombing raids headed

towards the north-east of England. Heading for targets in Newcastle and Sunderland, over 100 German Heinkel HE111s, accompanied by Messerschmitt ME110s, were intercepted by No. 72 Squadron Spitfires from RAF Acklington. Several Luftwaffe aircraft were downed with no losses to the RAF, and no more raids would follow from Norway.

The quieter skies of 1943 brought a change of role for the bunker as No. 13 Group was disbanded and the site downgraded to a sector operations room for No. 12 Group. The last large Luftwaffe raid was in March 1945, with twenty-six enemy fighter-bombers – more than all of the enemy aircraft detected in the previous year!

Following the Civil Defence Act of 1948, the bunker was used as a regional war room for the control of civil defence in the event of conventional or nuclear attack, and it continued in this capacity into the 1960s.

Still operational is RAF Boulmer, to the north of Alnmouth. Its RAF history began in 1940 when a site nearby was chosen as a 'decoy' base to lure Luftwaffe attackers from the operational RAF Acklington. The success of the Battle of Britain meant that the German air threat diminished and the plywood and canvas decoy Hawker Hurricanes were dismantled.

By March 1943 Boulmer had become a 'satellite' airfield of Eshott, near Morpeth, for No. 57 Operational Training Unit. Boulmer now had three tarmac runways and its pilots were trained on Supermarine Spitfires. In November of that year Boulmer became home to No. 9 Battle Training School and the skies over the River Aln were filled with Spitfires, whose pilots learned night flying, dive-bombing, strafing and chase tactics. There were several crashes, and a simple memorial to lost aircrew stands in a field near Longhoughton. Boulmer was closed after the war and the land was turned over to agriculture.

By 1953 there was an ominous new threat to Britain's security as the Cold War dominated world politics. Boulmer was again selected to play a major role in the UK's air defences with the construction of an air defence centre, with No. 500 Signals Unit coming under the umbrella of RAF Acklington. The following year saw the completion of the underground operations centre and RAF Boulmer became an independent station in its own right.

In 1957 the base became a Group Control Centre, and was responsible for radar stations at Buchan in north-east Scotland and Killard Point in Northern Ireland. A year later Boulmer received an equipment upgrade with high-powered Type 84 and Type 85 radars, which made up part of the new, centralised air defence system of the UK. This could penetrate the latest Soviet jamming technology.

From 1962 until the 1980s, Boulmer housed the Air Traffic Control Radar Unit, which coordinated military and civil air traffic. This closed when all Air Traffic Services (ATS) were concentrated on West Drayton and Prestwick.

As the UK's Air Defence Ground Environment evolved, Boulmer's role grew in importance and by 1974 it had become a sector operations centre and a control and reporting centre. Fighter controllers from Boulmer would routinely detect Soviet aircraft at the edge of the UK air defence region. Quick Reaction Alert (QRA) aircraft would be scrambled to intercept the Russians before they reached UK airspace. Boulmer's mission to detect unidentified aircraft continues today.

RAF Boulmer assumed another important role when RAF Acklington closed in 1975 and 'A' Flight, No. 202 Squadron, consisting of Westland Whirlwind search and

rescue helicopters, was transferred here. In 1978 the Whirlwinds gave way to Sea Kings, whose yellow livery was a familiar sight in the skies above the Northumberland coast for many years. Their 24/7 search and rescue remit covered the coast from Fife to Hartlepool and included the Lake District to the west, until they were replaced in 2015 by a civilian service controlled by the coastguard.

The Flight was involved in many high-profile rescues, including the Pan-Am Boeing 747 disaster at Lockerbie, attending the explosion on the Piper Alpha oil platform in 1988 and helping flood-hit Carlisle in 2005.

RAF Boulmer still plays a key role in the defence of the United Kingdom, watching over 1 million square miles of UK waters and airspace and beyond, warning of any suspicious activity. Using ground-based military and civilian radars, the Control and Reporting Centre (CRC) at Boulmer is responsible for the compilation of the Recognised Air Picture (RAP), which is essentially a radar picture of all aircraft within the United Kingdom airspace and its approaches. The CRC monitors the RAP 24/7, 365 days a year, to detect and identify all aircraft within it, and provides tactical control of the QRA Typhoons at RAF Lossiemouth and RAF Coningsby, which are launched to intercept unidentified or suspicious aircraft.

The final stop on our defensive journey through time brings us to the interesting story of a secret Second World War control station hidden below the remains of an Iron Age fort.

The summer of 1940 was clouded by the threat of a German invasion, so secret plans were made for a British equivalent of the French Resistance. Following the feared invasion, the intention was that volunteer spies and saboteurs would come out of their underground bases behind the enemy. These secret Auxiliary Units, of which Northumberland hid more than twenty, were intended as a last-resort measure. Fortunately, the services of these brave volunteers were never called upon in action.

The scheme began when Army intelligence officers were given the task of recruiting suitable men to work in small patrols. They were mostly miners and quarry workers for their expertise with explosives, and farm workers and gamekeepers (and poachers!) for their knowledge of the land. The Auxiliary Units' underground bunkers were called Operational Bases (OBs) and a standardised version was developed consisting of a semi-circular underground chamber measuring 30 feet by 10. At one end was an entrance shaft leading to the surface, and at Heiferlaw Zero Station some of the ancient stones from the Iron Age fort were used to disguise the entrance.

At Heiferlaw today it is possible to trace the ramparts of the ancient fort among the trees, and to locate the blocked off entrance to the secret bunker. Just over the fence is the medieval monastic watchtower mentioned earlier, so three distinct phases of Northumbrian defences can be found at one location.

Perhaps now at last the folk of Northumberland, after more than two millennia of 'being on the defensive', can rest easy. The county's unique position on a volatile frontier between two historically warring nations, as well as on a frequently invaded coast, means that our ancestors have left multiple layers of defensive history for us to explore and enjoy. Much of it is living history, which has been incorporated into later housing – some of which is private and therefore inaccessible – but we are left with a remarkable legacy of relics telling Northumberland's long and turbulent tale of conflict and uncertainty.

Heiferlaw has ancient and modern defences on one site; its Iron Age fort conceals a Second World War bunker.

Glossary

Bailey – see motte and bailey, below.

Barbican – usually a walled passageway in a castle gatehouse, defended by multiple gates.

Barmkin – the outer curtain wall of a fortification, surrounding its enclosure or courtyard.

Bastle – deriving from the French 'bastille', meaning stronghold, a bastle was a defensive farmhouse built in response to the raids of the border reivers in the sixteenth and seventeenth centuries.

Corbel – a projecting bracket of stone built into a wall, on which a platform, roof or parapet could be supported.

Licence to Crenellate – Royal permission to build a castle.

Machicolations – usually part of a corbelled projection with openings in the floor, often above a gateway or barbican, through which missiles could be dropped on attackers.

Moss-trooper – the rather euphemistic name given to mid-seventeenth-century Scottish outlaws, successors to the border reivers. They were often former soldiers and in gangs they would attack military and civilian targets indiscriminately, stealing livestock along the border and into Northumberland.

Motte and bailey – a Norman design of fortification, of which there are some examples in Northumberland. They consist of the motte, which was a man-made mound supporting a keep, often of timber, and the bailey, a fence or wall around the base of the motte.

Pele Tower – a fortified tower house, usually with a vaulted ground floor for livestock, with living quarters above for human occupants. They were often built to protect the local clergyman.

Reiver – a robber of the border territory who specialised in terrorising innocent people and stealing their cattle, sheep, weapons, clothes and money on a large scale. The reivers were not averse to murder and blackmail.

Sallyport – a gateway in a fortification, through which troops could sally (exit).

Solar Tower – several castles in Northumberland, such as Edlingham, boasted a 'solar', which refers to a room or suite that was designed for comfort rather than defence. It would typically be pleasantly furnished with tapestries and a fireplace.

Vallum – the ditch that was constructed to the south of, and parallel to, Hadrian's Wall. This was 20 feet wide and 20 feet deep and was situated between two parallel mounds. Together with the ditch to the north of the wall it is said to have marked the boundary of the military zone. North–south *vallum* crossings were built at each of the forts to guide cross-border travellers through their gates.

Vicus – a civilian settlement usually found just outside the Roman forts along the wall.

Bibliography

Tomlinson's Comprehensive Guide to Northumberland (1888), (republished by Davis Books 1985).

Ainsworth, S., Frodsham, P., Oswald, A., and Pearson, T., *Hillforts* (English Heritage, 2007).

de la Bédoyère, Guy, *Hadrians Wall – History & Guide* (Tempus, 1998).

McCombie, Grace, *Tynemouth Priory and Castle* (English Heritage, 1993).

Mee, A., *The Kings England: Northumberland* (Hodder & Stoughton, 1952).

O'Connell, Ben, 'Heiferlaw Zero Station' (*Northumberland Gazette*).

Sherlock H. and Short, O. M., *The History of the Tyne Electrical Engineers, Royal Engineers* (R. Ward & Sons, 1935).

The Castle of Newcastle-upon-Tyne (Society of Antiquaries of Newcastle-upon-Tyne, 1977).

Tuck, Anthony, *Border Warfare*, Department of the Environment Official Handbook (HMSO, 1979).

Websites

www.northofthetyne.co.uk/Castles.html
www.gatehouse-gazetteer.info
www.secretbunkernorth.org